BROCKPORT
IN THE AGE OF MODERNIZATION
-- 1866-1916 --

BROCKPORT
IN THE AGE OF MODERNIZATION
-- 1866-1916 --

WILLIAM G. ANDREWS

AMERICA
THROUGH TIME®
ADDING COLOR TO AMERICAN HISTORY

With gratitude to Mayor Margay Blackman who commissioned the "Historic Moments" that were the genesis of this book.

America Through Time is an imprint of Fonthill Media LLC
www.through-time.com
office@through-time.com

Published by Arcadia Publishing by arrangement with Fonthill Media LLC
For all general information, please contact Arcadia Publishing:
Telephone: 843-853-2070
Fax: 843-853-0044
E-mail: sales@arcadiapublishing.com
For customer service and orders:
Toll-Free 1-888-313-2665

www.arcadiapublishing.com

First published 2018

Copyright © William G. Andrews 2018

ISBN 978-1-63499-054-7

All rights reserved. No part of this publication may be reproduced, stored in a retrieval system or transmitted in any form or by any means, electronic, mechanical, photocopying, recording or otherwise, without prior permission in writing from Fonthill Media LLC

Typeset in Mrs Eaves XL Serif Narrow
Printed and bound by CPI Group (UK) Ltd, Croydon CR0 4YY

Preface

The purpose of this book is to present a study of the process by which a small American town was transformed in the fifty-year period between 1866, the first year after the Civil War, and 1916, the last year before American entry in World War I. It identifies fifteen developments that contributed to that process. It is intended to serve as a case study of that phenomenon. I am unaware of studies of that process in other communities. I do not know how typical the Brockport experience was. However, it seems very likely that most American small towns were undergoing similar developments during that period. Many details, of course, were different. Some actions that were controversial in Brockport may have been accepted readily in other communities—and *vice versa*. Differences in leadership and geographic situation may account for different experiences. But, basically, the process throughout the country must have been similar and this study may serve as the introduction to a very general phenomenon.

I have had the great good fortune on this project to be blessed by access to the nearly complete file of the weekly newspaper, *The Brockport Republic*. Only two years, October 1864–October 1866, are missing. The file is available as paper originals at the Emily L. Knapp Museum in Brockport, on microfilm at the College at Brockport, and online and searchable at nyshistoricnewspapers.org. The *Republic* did an amazing job of covering Brockport's news during that period and the fact that so much of it has survived and is so readily available is equally amazing. Without that source, this study would not have been possible. As I have drawn so heavily on that source, I have been very sparing in my endnotes. When I have used other sources, I have provided endnotes.

I have been greatly assisted in assembling the illustrations by Sue Savard of the Emily L. Knapp Museum in Brockport, Laura Emerson in the Drake Library at the College in Brockport, and Erica Linden, Deputy Clerk/Treasurer of the Village of Brockport. My son, Bill, Jr., provided essential tech support.

List of Abbreviations

BCI: Brockport Collegiate Institute
BR: *The Brockport Republic*
BRD: *The Brockport Republic-Democrat*
VBM: Village Board Minutes

CONTENTS

Preface	5
List of Abbreviations	6
1 1865 Brockport	9
Introduction	9
Physical Appearance	10
Who They Were	15
Government and Politics	20
Economy	28
Social Institutions	31
Cultural Life	33
Amusements	35
Fires	38
Accidents	38
Crime	39
2 Leaders	41
Dayton S. Morgan	41
The Gordons	42
William H. Seymour	44
Henry Seymour	45
Wilson Moore	46
George Barnett	47
Huntley and Johnston	48
Horatio N. Beach	49
Merritt and Milo Cleveland	50
Thomas Cornes	51
3 Infrastructure	53
Municipal Water	53
Municipal Sewers	57
Modernized Streets	60

		Cement Sidewalks	65
4		Utilities	69
		Telephones	69
		Electricity	70
		Home Delivery of Mail	71
5		Transportation	73
		A Modern Canal	73
		Bicycles	79
		Automobiles	81
		Trolley	86
6		Institutions	91
		State Normal School	91
		Union Elementary School	95
		Elections	99
		Fire Department	103
7		Conclusion	105
Endnotes			107
Bibliography			112

1
1865 Brockport

Introduction

Brockport is in the Town of Sweden, Monroe County, State of New York, 20 miles west of downtown Rochester. Hiel Brockway and James Seymour laid it out in 1822 at the intersection of Lake Road and the anticipated route of the Erie Canal, which arrived in 1823. Lake Road followed the path of an Indian trail from Leroy to Lake Ontario. Brockport was chartered as an incorporated village in 1829.

For two years, Brockport was the western terminus of the canal, while the ladder of locks was being built at Lockport. This gave it an early boost to become the most populous village in the county, a rank it still holds. It served as the market town and canal port for a large surrounding area. By 1830, the village had a population of 798, and by 1840, it had increased to 1,249.

In the 1840s, the character of the village changed rather dramatically as it became an important farm implement manufacturing center. That began in the late 1830s with threshing machine production. The big boost came in 1846 when the Seymour & Morgan foundry built the first 100 McCormick reapers. In the next few years, Brockport became the home of at least six manufacturers of farm machinery. They included the Johnston Harvester Co., whose plant was the largest factory in Monroe County.

Between 1846 and 1857, several modernizing events affected the village. The first, of course, was the rise of manufacturing in the late 1840s. Telegraphy arrived about 1850 and the railroad in 1852. Illuminating gas began to be produced in the village in 1859.

So, the modernization process really began some two decades before the period covered by this study. However, those changes were not nearly as transformational as those that occurred between 1866 and 1916.

The Civil War dominated village life in the early 1860s. The village was heavily involved in that great conflict, as I documented in *Civil War Brockport*

(History Press, 2013). The home front participated in wartime activities very extensively and some 863 men from the Brockport area served in the Union Army or Navy.

The year 1866 began the peacetime decades that ended in 1916 (the Spanish-American War caused hardly a ripple). Thus, those fifty years conveniently bracket the period of the modernization of the village. Modernizing events that occurred after that time required very little effort on the part of the village. Air travel, radio, television, and the internet simply seeped into village life from the outside. The real modernizing struggles that affected village life occurred in the 1866–1916 period. They are the ones described in this study.

The modernization process that this book describes began on the foundation of the village as it existed in 1866. The rest of this introduction is devoted to describing that foundation. This material is adapted from Chapter 9 of my *Early Brockport* book (Village of Brockport, 2005).

Physical Appearance

General

A striking feature of Brockport's physical appearance at the beginning of this period was the architecturally distinguished brick commercial blocks located on Main Street and Market Street in the central business district. Main Street was substantially rebuilt after a large fire destroyed sixteen business blocks in 1862. The elaborate design of the new commercial buildings and the speed with which they were built reflect a period of growing prosperity and optimism in the village.

Each year during the Civil War, as *The Brockport Republic* editor described it, "some new buildings are erected and old antiquated ones transformed into structures of modern style and attractiveness." The construction and renovation of village commercial buildings was explained, in part, by the merchants' desire to invest war profits in real estate. There was little confidence in the greenbacks issued by the federal government, and the merchants' experience with the notes of the Brockport Exchange Bank had done little to bolster their faith in paper currency. The extravagant ornamentation is also explained by steam powered tools. The sash factory in the village, for example, possessed a steam-driven carving machine "by which a great amount of ornamental work is reduced in price but a little above plain." Merchants also incurred the expense of ornamental embellishments in order to emulate their big city commercial competitors in nearby Rochester.[1]

Merchants who adorned their stores were automatically praised. When the Frye brothers rebuilt in 1863, the new structure was acclaimed as "the nicest store in Western New York" largely because, the newspaper editor wrote, "it

will be highly ornamental." The wood-frame Green Store, which had stood at the corner of Market and Main Streets for nearly fifty years, was hauled away and replaced with the present building. The ornate Cornes block came four years later. The canal-side building at 1 Main Street, erected in 1867, featured a handsome exterior with arched lintels, cast-iron storefront, and decorative wood cornice.

The first street lamps appeared in 1860, one year after gas began to be produced at the gas plant in the village. The cost of construction and fuel was at first met by private subscriptions. The first lamps were north of the canal, supplied by a line laid out to the house of Isaac Palmer, president of the gas works, in the adjacent town of Clarkson, to the north. The lamps illuminated North Main Street, where it passed the Johnston Harvester Works and the dubious neighborhoods of its employees, a fact that suggests a hidden motive of crime control in the street-lighting program. More street lamps were desired for the "pecuniary and moral advantage" they offered to the village, and they began to appear in better parts of town by 1861.[2]

During this same era, sidewalks along Main Street were paved with brick. Succeeding winters, however, left them "full of holes and of a very uneven surface." In the residential areas, they were made of planks—rotten for the most part and rickety.

The village was bounded on the north by Clarkson Street (now West Avenue) and Town Line Road (now East Avenue) along the boundary with the town of Clarkson. Adams Street marked the southern limit of the residential area. South of the railroad tracks east of Main Street were a hotel, half a dozen homes, and the fairgrounds. Only five residences ventured west of the Holley–Monroe triangle and the east edge of the High Street cemetery formed the eastern boundary of the village.

The population was heavily concentrated south of the canal. North of that waterway, North Main, Fayette, Liberty, and Berry Streets and the eastern end of Clark Street were fairly well lined with homes, businesses, and industrial works. Lyman, Barry, and Frazer (now Frazier) Streets had only a few scattered residences. Quarry Street and Clark Street west of present-day Smith Street appear on the map, but without structures. Slaughter Street is now Locust Street, but ran a couple of hundred feet further north and south to the canal bank and was unpopulated. Bailey Street ran from West Avenue to the canal about where Cherry Drive is now.

The Business District

The Brockport and Clarkson Plank Road, a private toll road, intersected the Town Line Road and Clarkson Street at a spot called Wilkie's Corners, named for Frederick Wilkie, a prominent merchant and one of Hiel Brockway's sons-in-law. On the right were three substantial homes of leading Brockport

businessmen and the reaper factory of Huntley, Bowman & Co. with buildings on both sides of North Main Street (in 1868, it became the Johnston Harvester Co.). The first of the homes belonged to H. W. Cary, partner in a hardware business that was manufacturing a rotary pump. Beyond Clark Street were three more modest homes and a structure owned by Elias B. Holmes, Brockport's leading citizen, but occupied by a blacksmith and a machinist. The last building before the canal was occupied by a "billiard saloon" and a livery stable.

The left (east) side of North Main Street, between Town Line Road and the canal, was developing as an industrial zone, with some of the Huntley, Bowman buildings and the reaper factory of Silliman, Brother & Co. Just to the east on Liberty Street was another reaper factory—Royce, Stevens & Holmes—that occupied the recently abandoned brass foundry of James Frazer. The east side of North Main south of Liberty Street had a building occupied by two grocery stores, two modest dwellings, a variety store, and (on the canal bank) a hotel.

The Main Street canal bridge was in poor shape in the early 1860s, the object of bitter complaints by the townspeople and the trustees and the cause of several injuries. The bridge at that time had a high arch to allow the passage of canal traffic. South on Main Street from the bridge most of the buildings were brick and the street was recently graveled, a very popular improvement over the mud and dust. Several businesses and some very modest homes—no more than hovels—occupied the canal banks and docks. Off to the east was the ever-growing reaper factory of Seymour, Morgan & Allen on Water Street at Market Street and to the west between Clinton Street and the canal was the farm implement plant of Whiteside and Barnett, which still stands.

Abutting the canal on the west side of Main Street was the village's most imposing hotel, the American. On the ground floor of the hotel was the barber shop of Anthony Barrier, whose daughter, Fannie, became a prominent civil rights leader in the Midwest, and a liquor store. Under the hotel with an entrance from the canal bank was George W. King's butcher shop. The top floor of the hotel was the Concert Hall, the largest assembly room in the village. The 1863–64 village directory shows nine boarders staying at the hotel, including Dayton S. Morgan, who was already a partner in the Seymour, Morgan & Allen reaper factory. He married in 1864 and moved with his bride into the Ostrom mansion as boarders.

In the short distance between the hotel and Clinton Street were four grocery stores, a jewelry store, and a variety shop at street level. Three of their proprietors occupied apartments above their stores. Also occupying second-floor space in those buildings was the print shop of W. H. H. Smith, who published for about nine years the *Brockport Daily Advertiser*, the only daily newspaper ever issued in Brockport, and the offices of two physicians.

Across Clinton Street was Joseph Sharpstene & Son's saloon and restaurant in the building occupied since 1929 by Barber's Grill and Tap Room. Then came three more grocery stores and another saloon and restaurant. Above

those businesses were a photography studio, two dentist offices, and two law offices, one housing Daniel Holmes, husband of Mary Jane, the famous novelist. Between those buildings and King Street were eleven more commercial buildings. Their ground-floor tenants included two hardware stores, still another grocery (ten so far), two boot and shoe merchants, a clothing store, a dry goods store, a harness-maker, and two stores that sold books and drugs. Among the upstairs tenants were two lawyers, a teacher, a photography studio, and a painter.

On the corner across King Street was the village hall, a two-story, side-gabled structure with fire equipment on the ground floor and village offices above. It had cost $2,500 to build in 1856, but had fallen into such disrepair that it embarrassed the villagers. It was demolished in 1873 and replaced by a bank building that was, in turn, replaced in 1927 by the bank building that still stands.

Between there and Erie Street were a grocer, a produce merchant, a milliner, a pump manufacturer, and a bank owned by two sons of Elias B. Holmes. Upstairs were a dentist office and residential apartments. On the corner of Main and Erie, next to the bank, was the Holmes House hotel and livery stable owned by Elias B. Holmes, but operated since April 1862 by Sharpstene. By 1865, he had moved from there to become the proprietor of the American Hotel. The top floor of the hotel was Holmes Hall, another large public meeting room.

Erie Street was the south boundary of Brockport's shopping district. Across it was Elias Holmes's handsome home and just beyond it, the Baptist church that had been built after its predecessor had been demolished in 1863.

The east side of Main Street was as bustling with businesses as the west. The corner of Main and State was occupied by a residence, but between it and Market Street were twelve commercial buildings. The first housed a physician's office and a millinery shop. Beyond it was a cabinet maker's shop and above that J. D. Fielding had his oil painting studio where he produced portraits of Brockport's elite. Then came a dry goods store with a dress shop above it and still another grocery. The next building had the Waters, Bishop & Co. bank, a flour store, and a millinery shop on the ground floor; a photography studio, insurance office, and *The Brockport Republic* on the second floor, with apartments above them. On toward Market Street were a clothier, a butcher, a jewelry store, and a building with a produce business and a hat shop on the ground floor and a dentist's office upstairs. The corner building was unoccupied, but by 1869 had become J. A. Getty's saloon, restaurant, and hotel.

Between Market Street and Water Street were a dry goods store with a lawyer's office upstairs, a clothing store, Austin Harmon's marble works with a justice of the peace above, and a building occupied by a flour and grain store and a harness maker. The latter three buildings, north of the present Bittersweet building, survive from that time.

Just north of Water Street were a boots and shoes store and a clothier. Then came eight buildings, the first four owned by J. Minot and the others by Thomas

Cornes. They were occupied by a dress shop, a whip and hat maker, Minot's clothing shop, a grocer, another clothier, two bakeries, a dressmaker, and a flour and grain merchant. Above one of the bakeries was the shop and residence of Troy A. White, dyer and hairdresser. Both White and Barrier, the other barber in the village, were African-Americans, as were almost all of Brockport's barbers in the nineteenth century.

In addition to Main Street's thirteen groceries, nine clothing and dress shops, and numerous other retail stores, a few other such businesses were located along the south canal bank and on Market and Clinton Streets.

Residences

According to the 1865 New York State census, most (82 percent) of Brockport's residences were of framed construction, but enough (14 percent) brick ones remained (mainly in the oldest, central part of the village) to lend credence to the legend that Indians in the area had called Brockport "Gweh-ta-a-ne-te-ca-nun-do-teh"—"the red village."[3] The residential building stock also included eleven "board" structures, four stone ones, and one "plastered."

In 1865, the dwellings units were overwhelmingly (75.9 percent) single-family homes, only 106 units (20.7 percent) were in two-family structures, six (1.2 percent) were in three-family, and eight (1.6 percent) were in four-family residences. Nearly half the multi-family buildings were concentrated in two neighborhoods. Brockport had no real apartment houses in 1865.

In 1865, Brockport had 512 households and 2,370 inhabitants, the average household size was 4.65 persons and only three (0.6 percent) of the dwelling units were unoccupied.

The 1865 census did not report any Brockporters as living in "group quarters." The only possible exception was the fifteen residents of the "Ostrom mansion," now the Morgan-Manning House. The census listed the owner, his wife, his mother, and twelve "boarders" who formed four family units. Also, the register of the Brockport Collegiate Institute listed thirty-one boarding students, who do not appear in the census. Apparently, they were enumerated at their homes. If those two households are counted as group quarters, they constituted 1.9 percent of the 1865 population.

If the residents of group quarters are not included, the percentage of married-couple families was 91.1 percent in 1865 and the percentage of the total household population who were children under eighteen years in married-couple families was 62.9 percent. The percentage of households with residents sixty-five or older was 13.1 percent. The percentage of female householders with no husband present was 7.3 percent.

In 1865, nearly one in four Brockport households was occupied by an extended family. That is, at least one member was not the householder, spouse, or a child of them. Also, 7.2 percent of Brockport households had domestic live-in servants and 7.4 percent had boarders.

The value of Brockport residences as reported in the 1865 census ranged from $150 to $6,500. That is, the most expensive home was worth forty-three times as much as the least expensive. The next most expensive homes (of which there were seven) were valued at $5,000. The next least expensive home was worth $175 and nine were given a value of $200. Accepting $200 and $5,000 as the more realistic figures, the high-end home was worth twenty-five times as much as those at the low end.

The median value (half of the homes were valued above this level and half below) of a home in 1865 Brockport was $900. The lower half of the housing stock had a value spread from $150 to $900, a $750 difference. The upper half ranged from $1,000 to $6,500, a spread of $5,500—more than six times as great.

A look at the housing market in terms of affordability shows that the wage for the employees of the village's street commissioner in 1865 was $0.875 a day. It required 1,028 days of work to earn the value of a median-priced home.

The census reported that 291 men and thirty women owned land, though it did not specify if the land was in the village or if it had any relationship to their dwellings. Twenty of the women were widows, who apparently inherited the property from their husbands. Six of them were single, two were married women not residing with their husbands, and two were married women residing with their husbands. Thus, it seems to have been legal for married women to own land in their own names.

Who They Were

Size and Growth.
The rate of growth of Brockport's population slowed further from 1850 to 1865, when the census had reported a total of 2,370 inhabitants. It had grown by 57.7 percent a decade in the 1830s and 41.4 in the 1840s. In the ensuing fifteen years, it added 604 persons for a total of 2,974, but the growth rate dropped to 22.8 percent. The number added since the 1855 census was 227 a 10.6 percent growth rate in that decade. The gender ratio shifted slightly back toward the females, they now had 51.9 percent of the population.

The geographic limits of the village did not change during that period, so the population density increased, from 1,358 per square mile to 1,823, giving the village a still more urban appearance.

Racial Profile
Brockport in 1865 had little racial diversity. Three or possibly four African-American families lived in the village. Two families, the Barriers (husband, wife, and three children) and the Cones (husband, wife, six children, a sister-in-law,

and five grandchildren), were identified as "mulatto" in the 1865 census. The BR called Troy A. White, a barber, "black." He was a widower, living with his nine-year-old daughter, a sister-in-law, and a journeyman barber. The census identified all of them as white, but that seems unlikely. Also, four female domestic servants were listed in the census as "mulatto" or black. Finally, the BR referred to Elijah Campbell and Daniel Williams as "colored."[4] Campbell does not appear as a surname in the 1865 census, but it lists a Daniel D. Williams as a white householder with a wife and mother. If the White and Williams households are included, there was a total of perhaps thirty African-Americans, 1.3 percent of the population. No other Brockporters appeared in the 1865 census as any other race than Caucasian.

Agriculture

Brockport's urban character was reinforced between 1850 and 1865 by the further decline in the share of the labor force employed in agriculture, from 8.6 percent in 1850 to 7.7 percent in 1865. This was the case, even though the number of persons who identified themselves as farmers or farm workers increased from thirty-seven to fifty-eight. Many of the 1865 farmers must have owned farms outside the village or they may have been retired.

Despite the urbanization, some farming continued to be carried on within the village limits. The census listed fourteen farms within those boundaries, totaling 462.25 acres, more than half (55.3 percent) the area of the village. The farms ranged in size from six acres to 109. Seven of them were less than 12 acres. Five of those farms were worth much more than any residence in the village, ranging from $8,000 to $14,000, compared to $6,500 for the most valuable residence. The other nine were valued from $1,000 to $5,000.

Barely a third (37.4 percent) of the acreage was cultivated in 1865. The rest was pasture or meadow. The main crops were corn and potatoes, but substantial quantities of beans and apples were also produced. Dairying was a minor activity, only thirty-three milk cows being enumerated, and no cattle were raised for beef. Only thirty horses were counted, ten of them on the farm of Elias B. Holmes, who bred race horses. Poultry were a big cash crop for the times. Chickens valued at $3,800 and eggs worth $5,700 were sold in 1864. Not all the Brockport livestock was on farms. The census reported 100 horses and 103 cows held by non-farm households. Also, *The Brockport Republic* mentions chickens, turkeys, and geese in the village.

Birthplace Profile

The birthplace profile of Brockporters changed dramatically between the 1850 and the 1865 censuses. The percentage of foreign immigrants rose from 17.9 percent to 22.7 percent. If minor children residing in households headed by immigrants are included, the percentage rose from 26.4 percent to 42.4 percent. Thus, nearly

half the population resided in immigrant households. Also, the percentage of Brockporters born in New York State (including the children of immigrants) rose from 58.3 percent in 1850 to 66.1 percent in 1865, but those born in other states fell by more than half, from 23.9 percent to 10.8 percent. Foreign immigration rose and the domestic sort fell. Indeed, 39.3 percent of 1865 Brockporters had been born in Monroe County. Obviously, this was the result of the settlement of the area.

The largest group of foreign immigrants came from Ireland. They accounted for 9.4 percent of the population. With their U. S.-born children, the percentage nearly doubled to 17.9. Canadians were next with 5.9 percent and 6.6 percent, followed by English (3.8 percent/5.5 percent), and Germans (3.1 percent/5.9 percent). Mixed marriages between Americans and foreigners were fairly common. When they are factored in, the residents of households with at least one immigrant parent account for the following percentages: Irish 19.3 percent, Canadian 8.8 percent, and English 6.5 percent. There were no German–American couples. There were also seven German–Irish, three English–Canadian, twelve Irish–Canadian, two American–Scottish children, and three by an Isle of Man–American couple. Other immigrants included a Swiss couple with two children, five Scots, four adults and five children from the Netherlands, and one South American (with, however, an English name).

The substantial immigrant population had an effect on the illiteracy rate. About 4.2 percent of the population over nineteen years of age were illiterate (that figure is not quite exact, because the census used over twenty-one years of age.) Forty-nine of the fifty-five illiterates were foreign born, forty-one of them in Ireland, four in England, three in Canada, and one in Switzerland. Three illiterates were born in Vermont, one in New Hampshire, and two were "mulattoes" born in Oneida County. Thus, 18.5 percent of the Irish-born immigrants were illiterates over the age of twenty-one, whereas the comparable figure for native-born Americans was only 0.4 percent.

Finally, in terms of personal characteristics, the census reported that two Brockporters were blind, two were "idiotic," and one was insane—not bad for a population of 2,370.

Age Profile

The age structure of Brockporters changed little between the 1850 and 1865 censuses. Half again as many lived to age fifty and a few more survived to become very old, seventy and over, while the twenty to twenty-nine bracket had shrunk by one-fourth. Otherwise, the changes were statistically insignificant. The gender differences were, also, not that great. In the 1865 census, boys under ten outnumbered girls, 292:256, but women overtook men in the twenty to thirty-nine age group, 410:301. Even the over-sixty-nines were virtually equal at twenty-three men to twenty-five women. However, six women and only one man lived to eighty (sixteen people of the 2,370 are unaccounted for).

Marriages

The census report on marriages in the year before June 1, 1865, is difficult to interpret. It lists only three marriages of village residents and fourteen of residents in the second election district outside the village. That seems difficult to believe, as 85 percent of the second election district residents lived in the village. Eleven of those seventeen weddings took place in the village, three in Sweden, and one each in Albion, Holley, and Clifton. That total was a decline from twenty-five in 1854–55 despite the growth in population in the interim. The drop may be the result of the absence of nearly fifty servicemen, many of whom were single of marriageable age. The average age of the grooms in 1864–65 was 31.5 years and the median age was twenty-eight. The average age of the brides was 22.6 years and the median was twenty-two years. The average gap in the couple's ages was 8.9 years and only one bride was older than the groom (by one year). Three of the grooms were widowers (two aged fifty and one forty-six) and all the other marriage partners were single. None were divorced.

Occupations

The 1865 census included absent members of the armed forces whose homes were Brockport. It showed that 798 (33.7 percent) of the total population was gainfully employed, a slight drop from 33.9 percent in 1850, despite the inclusion of sixty-three women. The figures disclose some significant changes in the fifteen years. The percentage of artisans fell from 43.7 to 34.2 percent, the share of tradesmen (businessmen) rose from 7.6 to 11.1 percent, manual workers rose slightly (18.9 to 19.3 percent), professionals grew from 6.0 to 7.0 percent, white collar workers (not including domestic servants) dropped from 7.6 to 4.0 percent and from 10.5 to 10.2 percent when servants are added. Due to the inclusion of military servicemen in 1865, the miscellaneous category rose from 13.3 to 18.2 percent. Without them, the 1865 percentage is 12.2 percent.

Within those categories, a number of trades showed important changes. Some resulted from technological advance. Brockport now had a photographer, three railroad employees, five engineers, and four telegraphers. Progress in farm implement manufacturing seems to have led to the replacement of sixteen molders by seventeen machinists. New types of business included newspaper publishing, banking, and lumbering.

Most of the women were employed in traditional female occupations. The "Population" schedule in the census listed forty-one maid servants, seven milliners, four dressmakers, two "tailoresses," and five teachers. However, the "Industry other than Agriculture" schedule enumerates twenty-six women employed in the clothing industry and two who worked for a whip and mittens maker. As commuting, even from the Town of Sweden, seems to have been nonexistent, some fifteen women apparently were not supplied with occupations in the "Population" schedule. Taking as realistic the figures I have deduced

from the 1865 census, sixty-one of the 715 women over the age of twenty (8.5 percent) were employed.

Besides the women employed in female occupations, two telegraphers were women, as was an artist and a produce merchant. The produce merchant was Mary Doane, a thirty-year-old single woman who was also one of the six single women in the village who owned land and one of two who were recorded as voters. Probably, some women who had occupations, in addition to the clothing workers, were omitted from the census. This was the case of Mary Jane Holmes, whose writings had made her the most famous resident of the village, but was given no occupation by the census. Five men gave their occupations as "none," but no women were so identified.

The number of domestic servants increased from eight (3.1 percent of the labor force) in 1850 to forty-four (5.8 percent) in 1865, perhaps reflecting increased prosperity in the village. Women servants numbered forty-one and men only three. Elias B. Holmes, the wealthiest Brockporter, employed two female and two male servants. Twenty of the women servants were Irish, fourteen had been born in the United States (including one African-American), four were Canadian, two were English, and one was German. Holmes's two male servants were native-born and the other man did not have his birthplace recorded. Three of the Irish female servants were employed by the American Hotel.

No commuters called Brockport their home in 1865. The census asked respondents if they worked elsewhere than in the village. Only the twelve employees of the New York Central Railroad said they did.

Mortality

The census taker remarked that "There has been no noticeable change in the average mortality during the past year. It will be observed that a large proportion of deaths in this locality were from pulmonary disease." Thirty-one Brockport civilians died in the year ending June 1, 1865. This was a rate of 13.1 per 1,000. The leading cause of death remained consumption, accounting for nine cases. Pneumonia, heart disease, and diphtheria were listed three times; drowned and typhoid fever twice each; and asthma, brain congestion, worms, brain fever, inflammation of the brain, convulsions, pericarditis, croupe, and cancer once each.

Fourteen women and seventeen men died in 1864–65. One of the two who drowned was a year-old boy. The other was a Canadian-born boatman of undetermined age. Childhood deaths showed a significant decline from 43.2 percent of the total to 32.3 percent. Still, the age structure seems curiously inverted. Most deaths (54.8 percent) occurred before the age of forty. The eldest person was seventy-one years. The median age at death was twenty-five years.

In addition, eight servicemen from the second election district of the Town of Sweden, which was mostly within the village, died in the year ending June 1,

1865. When they are added, the cause of death profile changes significantly, but the median age at death remains twenty-five years. Three military deaths were blamed on "starvation and diarrhea," one on starvation, and one on "chronic diarrhea." One soldier was "shot on picket," one died of typhoid fever, and the cause of death of another was not given. So, 85.6 percent of the Brockport soldiers whose cause of death was known suffered from disease and only one (14.3 percent) died from enemy hostilities. As all the soldiers were male, the addition of the service deaths changes the gender balance to 64.1 percent male and 35.9 percent female.

Government and Politics

Government

During the 1860s, village government remained a very small operation compared to our times. The streets, fire department, police, and the "burying ground" were its main concerns. An average of nearly half (48.6 percent) of its budget went for the streets. If the cost of the gas to light some of those streets is added for the four years when it appears in the budget, the share rises to two-thirds (67.0 percent). Moreover, the village consistently turned a profit on the burying ground. It averaged $83.25 for the five-year period. If the charges for the burying ground are deducted from the village's expenditures, the average total expenditures are $1,081.69 and the share for streets and gas becomes 72.1 percent. If the burying ground profits are deducted from the total village expenditures, the percentage devoted to the streets rises to 77.9 percent. This should make clear the extent to which streets absorbed the village budget.

That impression is reinforced by a review of the proceedings of the village trustees. The most frequent agenda item was the authorization of payments to employees of the street commissioner. Another item that appeared on most agendas was a resolution requiring the construction or repair of a sidewalk.

Similarly, when gas street lighting became available, the trustees asked the voters to approve a $300 tax to pay for the installation of lamp posts. When that was defeated, they invited residents to erect and equip lamp posts and the village would pay for the gas. That payment was authorized by the April 1861 election and, in six months, seventeen lamp posts had been installed by residents.[5] So much for big government!

The pay of elected officials is another example of minimal government. The clerk was the only officer who received a flat-sum (of $25) annual salary equal to about twenty-eight days' pay for the street commissioners' workers. The police constable seems to have been paid on an "as needed" basis. No payments were made to him in 1861–62 or 1862–63 and the payments in the other years ranged from $20.00 to $48.50. The street commissioner was also paid only for the days he actually

worked, at the rate of 10 shillings ($1.25) a day.[6] The tax collector received 1 percent of his collections for all taxes paid within fourteen days of the due date and 5 percent for all those paid thereafter. If all taxes were paid within fourteen days, his commission would have averaged $10.90 a year over the five-year period.

Popular voting at the village level seems to have taken two forms. First, each polling day seems to have begun with a meeting of all eligible voters at which trustees presented any resolutions that, under the 1852 charter, required referendal approval, namely the assessment of any tax of more than $200. For instance, on April 3, 1860, "At the opening of the rolls," Thomas Cornes presented a resolution "that we authorize the trustees to levy & raise a tax of Three Hundred Dollars for the purpose of lighting the Streets with gas, if in their judgment they may deem it advisable so to do. The resolution was, after discussion, put & Lost." Second, the election of officers seems to have been done by paper ballot throughout the day. This seems to be a change from the practice in the early years of the village, when the election of officers took place in a meeting, apparently *viva voce* or by show of hands. The first reference to ballots in the Sweden town board minutes is March 2, 1841. Before that the typical phrase was "were at such meeting duly elected."

The referendum questions during this period were as follows:

1860: Authorize a $300 tax for gas street lighting—lost by a large majority.
Authorize a $1,500 tax for a new fire engine—lost by a large majority.
1861: Authorize a $200 tax for gas street lighting—carried 229:104.
Authorize a $300 tax to build reservoirs—carried unanimously.
Authorize a $200 tax to buy apparatus for the fire department—carried.
1862: Authorize payment for gas street lighting without a special tax—carried 195:70.
1863: Authorize a $1,000 tax to buy a fire engine—lost by ballot vote, 112:104.
Authorize a $200 tax for gas street lighting—carried by ballot vote, 153:69.
1864: Authorize a $300 tax to continue gas street lighting—carried
1865: No referendal resolution

Charter Amendments

A major governmental event in these years was the adoption of amendments to the village charter in 1864. The process by which they were considered offers some insight into the flavor of Brockport's democracy at that time. As reported in the BR, the trustees "had requested the Clerk to write amendments to be submitted to the board or prominent citizens; but unbeknown by the Trustees they had been sent to Albany." Upon learning this, the trustees posted notices for a public meeting open to all qualified voters.[7]

Thomas Cornes, the village president, opened the "well attended" meeting by nominating Austin Harmon, who was not a village official, to chair it. After brief discussion, the meeting referred the proposed amendments to a committee composed of Cornes, Trustee George B. Whiteside, former Trustee Frederick W. Brewster, and two "prominent citizens" (Jerome Fuller and Ansel Chappell) with instructions to report back to the adjourned meeting a week later.[8]

The adjourned meeting convened as scheduled: "About eighty persons were present, composed about three-fourths of what is denominated workingmen, and about one-fourth merchants and heavier tax-payers."[9] The committee had agreed unanimously on a revised set of proposed amendments. The meeting adopted "by a large majority" its proposed provision creating an "inspector of wood," who would ensure that wood being offered for sale was measured accurately. Next, it approved "nearly unanimously" an amendment strengthening the powers of the trustees to require the construction and repair of sidewalks. Then, by a 3:1 majority, it passed a measure authorizing the trustees to raise a $200 contingency fund. The committee had proposed authorizing the trustees to levy a $400 highway tax. Cornes moved that the amount be raised to $600. His substitute amendment was defeated "by a large majority" and the committee's proposal "adopted by a like expression." Next, the committee's proposal to authorize a $300 fund for lighting the streets with gas was "voted down by a large majority." This led to the following exchange that seems to capture well the political mood of the day.[10]

> Mr. Cornes thought the people did not understand the matter.... The people had voted it at the charter election for the past three years, would vote it again; but this section would save the trouble.
>
> A man whose name we do not know said that Mr. Cornes wanted everything his own way. He said that as they paid for gas, they wanted a lamp post over in Canada—over the canal.
>
> Mr. Cornes replied that he paid for the gas post in front of his house, and would give $3 toward a gas post over the canal.
>
> John Efner said that the people of any neighborhood could have the streets lit with gas by erecting a lamp post.
>
> Isaac Bradt said it was very well to talk about the people having the streets lit with gas on some of the distant streets by the erection of lamp posts; but who in the devil should lay the pipe!
>
> The Chairman directed that another vote be taken on the gas appropriation by a "division of the house." The man from "over in Canada" loudly demurred against another vote, as the amendment had been once voted down. A count was taken; thirty-four being for the appropriation and thirty-eight against.

After further heated discussion, the committee's recommendation that the Street Commissioner's pay be set at $1.50 a day was adopted. Finally, the committee presented a new provision authorizing the trustees to make extensive street improvements upon petition of two-thirds of the owners of adjoining property. It carried by 34:32. The meeting ended this way:

Expressions were made doubting the correctness of the count.
A motion was made to adjourn. Lost by the usual vote.
The Chairman announced that the people could remain as long as they pleased. All left notwithstanding the emphatic vote against an adjournment.

On May 4, 1864, the New York State legislature passed "AN ACT to enlarge the powers of the trustees of the village of Brockport."[11] It enacted, in substance, all the amendments considered at the public meeting, including the one that was defeated, except the one creating a post of "inspector of wood," which had been the most popular proposal before the Brockporters.

Voting

The 1865 census counted 397 native-born and 124 naturalized registered voters for a total of 521 in a total adult male population of about 588. Thus, the 1865 electorate formed about 88.6 percent of the voting age male population. The number of votes cast for village officers were: 1861, 386; 1862, 338; 1863, 256; and 1864, 254. The numbers for 1860 and 1865 are not available. As the numbers of registered voters changed from year to year and are available only for 1860 and 1865, no precise figure on turnout can be produced. However, it appears that it declined from about 60 percent in 1861 to below 50 percent in 1864. The number of men of voting age who were serving in the army would account for most of the drop. Quite surprisingly, two women are listed as voters in the 1865 census. One was Mary Doane (mentioned above) and the other was Lydia Wright, a twenty-seven-year old single woman with no occupation indicated. Another indication that Brockport's women in the 1860s were not completely passive politically is the report that the Republican celebration of Lincoln's victory in 1860 was "composed about half of each ladies and gentlemen."[12]

The Republicans and Democrats had active party organizations in the village and the town. During this period, the town elections tended to be partisan, but the candidates in the village elections used non-partisan labels. Some deviation from those generalizations occurred. For instance, in the town elections of 1861, there were two tickets, Republican and People's. Initially, the Democrats rejected a People's ticket in 1860, but later joined it, with a sprinkling of Republicans and American (Know-Nothing) members.[13]

The 1861 town elections were contested by a straight Republican ticket and a "ringed, streaked, and speckled ticket composed mainly of Democrats." The Republicans won every office, except one of the five Constables, who was a Republican on the opposition list.[14] Three all-Republican tickets with virtually-identical candidates and a "People's Union" ticket, composed of seven Republicans and six Democrats, fought the 1862 elections. All successful candidates were Republican, except that Democrat Thomas Cornes was elected Supervisor.[15] In 1863 and 1864, only single Republican and Democratic tickets were present, the GOP—running under the "Union" label in 1864—winning all offices by large majorities.[16] The results of the 1865 town elections are not available.

The non-partisan tradition for Brockport village elections may have originated or been revived at this time. Both major political parties had nominated candidates for village office in the late 1850s and the Democrats did so in 1860. In fact, their candidates won all five trustee seats and five of the other eight village offices.[17] The situation changed in 1861. Several tickets entered the lists. However, although Beach identified three of the successful trustee candidates as Republicans and two as Democrats, he insisted that the election "in no sense was a party one."[18] In 1862, five tickets contested: Citizens', People's Union, two People's, and Union. However, the Citizens' and People's Union ran the same candidates, winning all offices, and Daniel Holmes appeared on all five lists for village clerk.[19] In 1863, four tickets ran, with Union being replaced by People and Firemen's.[20] In 1864, only two tickets were present, Patriotic and Union, with the former carrying all offices except Street Commissioner.[21] According to the BR, the last three elections, like that of 1861, were non-partisan.

The disappearance of party nominations coincided with a movement to unite behind the war effort. The Republicans seem to have sought to draw pro-war Democrats into a kind of Unionist coalition. This was best accomplished under a non-partisan label. The Democrats who resisted the coalition became a minority. Probably, having little wish to expose their weakness, they, too, ceased nominating village candidates. As the war progressed, the "Union" movement strengthened. It began officially in September 1861, with a public meeting that summoned "All who regardless of Buffalo platforms, Chicago platforms and Cincinnati platforms are willing now to stand upon a great National Platform, devoted solely to the maintenance of the Union." Its sponsors included leaders of both major parties, but the most prominent Democratic leader, Thomas Cornes, was conspicuously absent from the list of sponsors and from the list of officers elected at the meeting.[22]

The Union meeting in Brockport reflected a statewide—and probably national—movement. The state Republican Party had decided not to nominate candidates separately from the Union ticket. As presented in the BR, the Union movement was initiated and controlled by Republicans. It reported that, at the

county level, "the Republicans are disposed to grant to the Democrats either the County Clerk or Sheriff, and one of the Associate Judges, and one or two of the Coroners. This is certainly fair, and should be accepted by them." As nine county offices were to be filled, the Republicans were reserving the lion's share for themselves.[23]

Although the Republicans were holding a separate county convention, its "main object ... is to keep up the party organization."[24] As it turned out, the effort for union only partly succeeded. The People's Union nominated candidates for all nine offices and all of them won, including Democrat James Warren for Sheriff. However, the Republicans ran a nominee for sheriff and two for coroners and the Democrats nominated a candidate for Assemblyman.[25]

By 1862, the pretense of non-partisanship above the village level had been dropped and the "People's Union" ticket had become a "Republican Union" list and the labels "Republican Union," "Republican," "Republican and Union," and "Union" were used interchangeably for the rest of the war. At the national level, President Lincoln ran for re-election in 1864 as a "National Union" candidate with Democrat Andrew Johnson as his running mate. The non-partisanship at the town, state, and national levels was transient, but became a permanent feature of electoral politics in the village, surviving until the present time.

Campaigning

Politics in Brockport were lively during the early 1860s. The 1860 election campaign was especially hard fought. As early as February, the BR proposed that a "Republican club" be organized in Sweden "soon after the town election" to "secure a brilliant triumph" in the fall voting.[26] No report of such an organization appeared in the BR until the end of June—nearly four months after the town elections—when it held "an old-fashioned Ratification Meeting" to celebrate the nomination of Abraham Lincoln. The Democrats held a similar event for Stephen A. Douglas's selection as their presidential nominee.[27] In August, a "Lincoln and Hamlin Wide Awakes battalion" was organized with ninety charter members (increased to 100 a week later) and former Congressman Davis Carpenter as their "commander."[28, 29]

"The Presidential campaign was most brilliantly and enthusiastically inaugurated" in Brockport on August 17 "by the convening of several hundred ardent, earnest Republicans—who are ready to battle for the cause of freedom, and the rights of humanity until they shall have gloriously triumphed." About seventy Wide Awakes "turned out with banners, transparencies, and glowing torches" and paraded on streets "filled with people assembled to get a view of them" in their $1.50 uniforms of "a plain glazed cap with a reddish band, and a short round cloak manufactured of glazed cloth." The rally was replete with martial music, songs by the Republican Quartette Glee Club, and two hour-long orations at the Concert Hall, which was "filled to its utmost capacity."[30] A

week later, a similar rally in West Sweden drew 1,500 participants and five Wide Awake clubs from neighboring towns.[31]

The Democratic campaign for Douglas began about the same time. A Clarkson–Sweden Democratic Club and a Little Giants club, similar to the Wide Awakes, formed in late August, but did not parade until September 17, when they finally got uniforms, borrowed from the Lockport Douglas Guard.[32, 33] From that time until election day, the chief campaign activities in the village seem to have been popular rallies and competitive marches by the two militias through village streets each Monday. At least as reported in the BR, the Republicans had four mass rallies during the last month of the campaign and the Democrats had two in the last six weeks. Each lasted for several hours and included brass bands, cannon fire, fireworks, torchlight parades, militia drills, several hour-long speeches, and glee club singing. The militias exchanged visits with their counterparts in neighboring towns, so that they sometimes numbered 300–400. The Republicans also had a boys' organization, called the Young Rail Splitters, though its existence was not reported until after the elections. Lincoln carried the town, with 571 votes to 264 for Douglas's "Fusion" ticket.[34] The 1864 presidential campaign was much less lively, at least through September 29, which is the last date for which a BR has survived.

Caucuses and Conventions

One indication of the liveliness of political life in Brockport at that time is the frequency of party caucuses and conventions, mainly for choosing candidates for public office and delegates to the next level up in the party hierarchy. Both parties had frequent caucuses at the village and town levels. Then, there were annual conventions at the county, assembly district, judicial district, and state levels and biennial congressional district and quadrennial national Presidential nominating conventions.

The local caucuses were very well attended. For instance, 257 votes were cast at the Republican town caucus to pick delegates to the assembly district and county conventions in September 1860, almost one third of the registered voters.[35] Earlier that year, a Republican caucus to nominate town officers was attended by "about 250" men, 60 percent as many as voted for their town supervisor candidate in the election that followed.[36] Another had 224 votes cast for electing a town committee.[37]

Most of those party meetings resolved contested nominations, but they seem to have been quite routine, with few overt conflicts. At one Assembly District Convention, the "balloting was spirited, but harmonious."[38] At a Republican town caucus, the winning slate of delegates polled 144 of the 257 votes, suggesting a lively contest.[39] However, a Congressional District convention that was held in Brockport was a "great row ... only befitting the plug uglies of New York." The partisans of Alfred Ely, the incumbent, arrived at the hall early and

claimed control of the meeting. When the supporters of Freeman Clarke arrived, they, too, convened a meeting. The two meetings proceeded simultaneously in the same room in "great confusion and disorder."

> There were loud cries of "order," and still the disorder increased until finally a melee ensued, in which both chairmen, the reporters, and many other persons were shoved from the platform. We have a vivid remembrance of just clearing with our feet the head of the reporter of the Rochester Union as we followed him to the floor, followed by the dry goods box which had been extemporized as a reporter's stand. Thrice were the officers crowded off the platform and for several minutes a general fight appeared to be going on.[40]

After a semblance of order was restored, Mr. Ely's partisans nominated him, 35:0, and Mr. Clarke's supporters, voted him in, with twenty-six of the thirty-three ballots cast and the others scattered among four persons. In the end, Clarke's name appeared on the ballot as the Republican nominee and he was elected. In fact, the *Biographical Directory of the American Congress* says that Ely "was not a candidate for renomination in 1862," which casts the efforts of his supporters in a strange light.[41]

Another indication of political activity is the number of men involved in politics. The BR lists 216 names of residents of the Town of Sweden in its reports of nominees for elective public office and holders of political party offices in the fifty-seven months of this period for which we have extant copies. This seems to be an extraordinarily large number men occupying positions of some leadership in a town no larger than Sweden was at that time.

Patronage

Patronage was another preoccupation of political life in Brockport at that time. As local government was so small, it had few spoils for the victors. The main appointive offices the politicians fought over were the postmastership and the canal collector. A new, Republican postmaster was almost automatically appointed once Lincoln had been inaugurated and Republicans took control from the Democrats.[42] The big plum, however, seems to have been canal collector. When the governorship went from Democrat to Republican in early 1860, eleven "good Republicans" vied for the office. The BR justified the spoils system this way:[43]

> As the Republican party is being built up and maintained by those men who are ever vigilant in laboring for its interest, its rewards should be bestowed accordingly. If those are rewarded who do nothing for the party, then the do-nothing principle will come in vogue, and the party under its influence will become extinct.

It soon became clear that Beach himself coveted the collectorship. When he was not appointed, he complained bitterly that the men who had been "have done no service for the party." He believed that to be especially true for the Brockport appointment and reported that the indignation in Sweden and Clarkson was so great that "about one hundred of the active Republicans" signed a protest resolution.[44] The office was abolished in February 1861 and reopened seven months later.[45] Again, Beach quarreled over the job. He finally got it in June 1862, but lost it again in February 1863 when a Democrat became governor.[46]

Prominent Visitors

Brockport's political life in those years was enlivened a bit by visits from some prominent political leaders. Stephen A. Douglas, the Democratic candidate for President in 1860, made a brief visit to the village on his whistle-stop campaign tour. Two-thirds of the 300 people who greeted him were Republicans wearing "Lincoln and Hamlin, and Free Territory" badges, according to the BR. He addressed a few, brief remarks to them, received the cheers of the Democrats, and continued his journey.[47] Earlier that year, Susan B. Anthony and Greeley held an "Anti-Slavery Convention" in Brockport. Apparently they aroused little interest, for forty villagers attended the first day and only twenty-five the second.[48] Two months later, an escaped slave, Oneida E. Day, spoke at another anti-slavery meeting that had a "fair audience."[49]

Economy

Prosperity

In general, the early 1860s were a relatively prosperous period for Brockport. The 1865 census reported that the average monthly pay in the summer was $23 and the average annual pay was $145, increases from $19 and $130, respectively, in 1860. Also, as a result of the war, the "amount of debt between individuals" had "become less," payments had become more prompt, and the value of farmland had increased by 15 to 20 percent. Yet, the census taker also commented that the war had contracted credit and that "pauperism probably increased." "Many families have been essentially improved in their condition by a few dollars because of the large bounties paid," but others "who entered the service early have been made more destitute by the loss of their heads" and have "become dependent on the Public for support."

Several signs of economic prosperity were reported in *The Brockport Republic*. The Brockport railroad station was the busiest on the Niagara line and its business increased greatly in the early 1860s.[50, 51] Eight trains in each direction called at the Brockport depots each day except Sunday.[52] Important improvements and enlargements were made to the Brockport facilities, including a new $1,000

double-track wrought iron bridge over Main Street that is still in use.[53] New passenger and freight depots were built during this period. Canal traffic and collections increased. Tolls paid in Brockport rose 49 percent from 1859 to 1860.[54] Gas company customers increased from ninety-two to 116 in the same period.[55] Throughout the early 1860s, nearly every storefront on Main Street was filled and very few dwellings were vacant.[56] The 1865 census reported only three vacant housing units among the 512 in Brockport's dwellings.

Another indication of prosperity was the amount of new construction undertaken in those years. Besides the 23,000 square feet of floor space in the Luther Gordon planing mill, Thomas Cornes built a three-story, 30×80-foot warehouse and Harrison & King built a "very substantial" grain storehouse.[57,58] Another new commercial structure was the drug store of T. and A. Frye, which "bids fair to be the finest store in the village."[59]

When the Ostrom block, one of the largest commercial structures on Main Street, burned in late 1860, it was promptly rebuilt.[60] Far more important was the reconstruction that followed the fire that destroyed the entire east side of Main Street between State and Market Streets in May 1862. By January, most of the commercial structures had been rebuilt and reoccupied and the last of them was underway in the spring.[61,62] Also, two churches were built during this period.

Also, many dwellings were built during this period. The most impressive was the "elegant" $1,000 home (still extant) that Luther Gordon built on Main Street at South Street.[63] Dr. Ralph Thatcher then hired Gordon to build "a very near facsimile" of his home across Main Street at the corner of Brockway Place.[64] This dwelling is still extant. Charles Brockway, eldest son of Hiel, also built or rebuilt his home on the corner of College and Main Streets.[65] Another Gordon residential project was the construction of homes along Gordon Street. The amount of construction led to a shortage of carpenters and masons.[66]

Farm implement manufacturing, a major pillar of the Brockport economy, did well during the early 1860s. The BR reported in late 1860 that sales in the West had been good and collections were the best in at least three years.[67] About 600 reapers were manufactured in Brockport during the 1861–62 winter, mostly for sale in the west.[68] The following winter, the production increased to 500 reapers and mowers by Seymour, Morgan & Allen, 300 by Silliman, Bro. & Co., and 200 by Stevens & Holmes for a total of 1,000 machines. In addition, Whiteside & Barnett manufactured a large variety of farm implements: "All the mechanics disposed to work have employment."[69] The next season was even better, with both Seymour, Morgan & Allen, and Silliman, Brother & Co. doubling their production and demand remaining strong.[70]

The increased activity required expanded plants. Whiteside & Barnett built a two-story 34×48-foot addition to its plant in 1860 and another building in late 1863.[71] Seymour, Morgan & Allen erected a new molding shop in 1860

and expanded it in 1863.[72] Royce, Stevens & Holmes entered the industry by repairing an idle furnace north of the canal in 1862.[73]

Another indication of prosperity in Brockport was the lively real estate market. The BR published reports on fifty-four real estate sales during this period. This does not include new construction. Seven properties were commercial, the rest were residential. At the midpoint in this period, the BR published an item commenting that "The plenitude of money is begetting a speculative feeling among the people in regard to real estate. There is more demand for houses and lots in this village than there has been for a long time previous."[74]

Although business slumped for a three-month period in mid-1861, it soon recovered and was reported as being good in late 1862.[75]

Banking

The banking business in Brockport during this period was quite unstable. The Brockport Exchange Bank went belly up in mid-1861 and the Brockport Savings Bank followed suit within six months.[76] They were replaced quickly by two others, Holmes & Brother and Waters, Bishop & Co.[77, 78] However, within a year, the Holmes brothers sold out to Waters, Bishop & Co. and went into the insurance and banking business in Chicago, and seven months, later Waters, Bishop & Co. was folded into the First National Bank of Brockport that Luther Gordon had organized.[79, 80] The FNB was much more durable. It built a handsome three-story building on the corner of Main Street and King Street in 1873, replaced it by the present bank building in 1927, and survived until the national bank holiday in March 1933.[81]

The banking instability occurred despite the fact that one of the banks was always the depository for Brockport canal collections. To some extent, this instability reflected the fluctuations in those collections. They amounted to $37,143 in 1859; $55,415 in 1860; $32,941 in 1861; $6,394 in 1862; and $10,341 in 1863. Those for 1864 are not available. According to the BR, the 1861 decline resulted from a change in the system for routing boats and did not represent a fall in business at the Brockport office.[82] The sharp drop in 1862 was caused largely by the abolition of the Brockport toll station from February 1862 until strenuous political efforts forced its reopening in July.[83] The reason for the continued low level in 1863 is unexplained.

The Fair

An important help for the Brockport economy in the early 1860s was the Brockport Union Agricultural Fair. It became more institutionalized during this period, obtaining incorporation in 1860.[84] In addition to the general agricultural exhibits that were scheduled for each fall, it began in 1860 to hold a Floral Fair and Horse Show in June.[85] Each year, it offered "premiums" for the winners in each of the many categories of entries. Typically, they amounted to

$1,000 or more. When its receipts did not equal the proffered premiums (which was usual), it reduced the premiums a proportionate amount. Each year, the financial situation improved and, in 1864, it declared a profit for the first time.[86] The big benefit for the village was the increased business that visitors transacted during the fair.[87]

Social Institutions

Churches

Much the most important social organizations in the village in the early 1860s were the six churches. This information about them appeared in the 1865 census:

Brockport Churches, 1865					
Denomination	Value of Church	No. of Seats	Usual attendance	No. of Communicants	Salary of Clergy
Meth. Episcopal*	$4,000	250	200	150	600
Baptist	$22,500	800	400	175	1,000
Prot. Episcopal	$9,715	350	100	70	600
Presbyterian	$15,000	1,000	400	175	1,000
Roman Catholic	$5,000	300	300	250	600
Evangelical Luth. Ref.	$1,000	100	30	10	---

*Official ME denominational statistics provided rather different figures for 1861: ninety-seven members, $3,000 in church property, 127 "Sabbath school scholars," $500 clergyman's salary.[88]

In addition to those congregations, which owned church buildings, two denominations held worship services in rented quarters. The Second Adventists met in the village hall and the Free Methodists used the building on King Street (still extant) of the Free Will Baptist congregation that had become defunct in 1863 or the village hall.[89]

The census also reported that the Town of Sweden outside the village had five churches (Presbyterian, Methodist Episcopal, two Baptists, and Free Methodist). Therefore, those denominations in Brockport probably drew few members from Sweden. The Roman Catholic and Lutheran churches were the only ones that might have benefited from that contiguous population.

By adding seventy to the total "usual attendance" supplied by the census to account for the Second Adventists and Free Methodists, the number of Brockporters found in church most Sundays was 1,500, 63.3 percent of the total

population of the village. This is very close to "about two thirds of the whole population" estimated by the BR, but a substantial drop from 1850.[90]

Most of the congregations had more than one service a week. The Baptists, Presbyterians, Free Methodists, and Episcopalians each had two Sunday worship services and the Methodists and Catholics had three. Also, the Baptists had three prayer meetings a week, the Methodists and Free Methodists each had two, and the Presbyterians had one. The Free Will Baptists maintained an organization, but "had no stated meetings."[91] The information in this paragraph and the one that follows predates the founding of the German Lutheran Church, which scheduled one worship service each Sunday.[92] Also, all the churches had special worship services on religious holidays like Ash Wednesday, Good Friday, Christmas, and Thanksgiving and the Catholics always celebrated St. Patrick's Day.

Finally, "protracted" meetings and camp meetings for the purpose of spiritual revival and conversions were held from time to time. The Baptists held a protracted meeting that met every evening. It had begun "two or three weeks" before February 9, 1860, and was still continuing on April 12.[93] The Free Methodists organized an annual week-long camp meeting in Bergen attended by as many as 10,000–12,000 members.[94] The mainline Methodists held similar meetings, but less regularly or frequently.[95]

The Sabbath Schools were an important part of the churches' activities. They reported the following numbers of teachers and scholars: Presbyterian thirty-one, 257; Methodist sixteen, 100; Baptist twenty-seven, 325; Episcopal fourteen, eighty-seven; and Free Methodist seven, thirty.[96] Also, there were a Baptist Ladies' Benevolent Assn., Presbyterian Ladies' Sewing Society, Episcopalian Ladies' Mite Society, and Free Methodist Ladies' Sewing Society.[97]

New Buildings

Two congregations erected new church buildings during the early 1860s. The more imposing was the Baptist church, which still stands, though much remodeled in the 1920s. The previous structure was demolished and the new one constructed on the same site, which earlier had been the location of the first cemetery in the village. Luther Gordon was the contractor and William White of Syracuse the architect. The cornerstone was laid on September 17, 1863, and the building was finished exactly a year later. The estimated cost was $8,000—$2,000 more than initially expected. The congregation had three-fourths of the amount in hand when construction began and had raised the rest by the time it was completed.[98]

The German Reformed Lutheran church was much more modest. It was built largely by the volunteer labor of its members without architectural guidance on Monroe Avenue at Perry Street, where the Hartwell Hall lawn is now. Construction began in November 1862 and the building was dedicated in May 1863.[99]

Social Activities

In addition to the ministers' salaries as reported to the census, the churches regularly organized "donation visits" to their homes to augment their income. The BR reported fourteen such events during this period. The amounts collected each time ranged from $100 to $204.

Besides the worship services, prayer meetings, and Sabbath schools, the churches engaged in active programs of social and fund-raising activities. Popular events that combined those purposes were oyster suppers, strawberry festivals, "benefit entertainments," etc.[100] The most popular purely social activity was the church "pic nic," often an annual event.[101]

Schools

The only organizations I have classified as "social," other than churches, that received attention from the BR during the early 1860s were schools and fraternal lodges. The BCI continued to play an important role in the community, but its finances were in desperate shape, even though it continued to enroll 120–150 students each term.[102] In fact, it was sold to a Professor Henry Fowler of Auburn at a sheriff's sale in 1863 and not recovered until 1866.[103] It was saved only by its 1867 designation as one of the original state normal schools.

The three district schools (east, west, and north) continued to offer elementary education. Also, Miss L. B. Comstock offered art classes privately and Mr. C. J. Wood taught dancing classes at the Concert Hall.[104, 105]

Fraternal Orders

The Masonic lodge was the only fraternal organization on the BR list. It seems to have been quite active, meeting the first and third Tuesdays of each month and claiming sixty-eight members.[106] However, the BR news columns also report activities by four similar groups. The Sons of Malta held a ball in February 1860 that was attended by a "fair number."[107] The Sons of Erin observed St. Patrick's Day annually.[108] The Loyal League and the Union League leased space in the Masonic lodge's quarters. The latter was an organization, originating in the border states to show the support of its members for the Federal Union after the outbreak of the Civil War. They seem to have been ephemeral associations.[109]

Cultural Life

Societies of Note

Brockport's cultural life was surprisingly rich for a small town in rural New York at that time. The BR listed fourteen "societies of note" in the village. They included the seven churches (Baptist, Methodist, Presbyterian, Episcopal, Free Methodist, Free Will Baptist, and Catholic), the ladies societies attached to four

of them (Baptist, Presbyterian, Episcopal, and Free Will Baptist), the Masonic Lodge, Young Men's Christian Association, the Brockport Music Association, and the Young Men's Literary Association.[110] In addition, a Debating Club was revived later and the trustees minutes indicate that an "Advent society" existed in the village.[111, 112] This did not include, of course, the BCI, which was certainly the most important cultural institution in the village.

Lectures and Debates

The cultural organizations that were most active (or, at least, received the most space in the BR) were the YMCA and YMLA. They brought nationally-prominent speakers to the village. The YMLA focused on intellectual and cultural topics. The YMCA was concerned with religious and moral issues. The lectures and readings, sponsored by them and by other organizations, during this period ranged from scientific topics to spiritualism. They averaged about one lecture each two months, as some speakers gave a series of talks and others made return engagements.

In addition to the lectures and readings, the YMLA organized some debates. It planned a public debate every Tuesday evening at the village hall, but the BR reports indicate that such an ambitious schedule was not maintained.[113] The debate topics included the value of "the lecture system," "universal salvation," and "Universalism."[114]

Despite the generally-large audiences that the BR reported, the lecture associations were always on the brink of insolvency. Early in 1860, the YMLA published a financial statement in which it reported having paid $240 for eight lectures plus other expenses with receipts of only $180 and it cancelled the last four lectures of its series for lack of funds.[115, 116] That fall, the BR reported that it had become defunct.[117] Nevertheless, a month later, it rose from its ashes, appointed Beach to its committee without his knowledge or consent, and announced a lecture series.[118] The YMCA had similar financial problems. In its 1860–61 season, it just broke even, both receiving and spending $346.[119]

Other Cultural Activities

Besides those programs, Brockport was the site of occasional visits by touring cultural groups. The BR reported that the Broyer's Theatrical Company and "the celebrated Tragedian and Shakesperian Reader, Fredericks," would perform in the same week.[120] However, the thespians closed two weeks later for lack of patronage.[121] The BR seems to have reported on only those commercial cultural events that were advertised in its pages. The village trustees licensed all such activities and their minutes show that a Denin Theatrical Troupe was permitted to perform in the village in July 1861.[122] The BCI was also a source of cultural events. Each of its three terms each year ended with a public "exhibition" at which students and faculty presented intellectual, cultural, and musical

performances. The BCI was closely integrated in the life of the village. In fact, it was literally owned by local people. Thus, they attended the exhibitions in significant numbers.

Another cultural activity in the village was musical performances. A Musical Association existed, but the BR reports only one performance by it, with twenty-eight voices, to a "full house" in June 1860.[123] Other musical groups in the village included the Brockport Band, the Brockport Glee Club, the Sweden Silver Band, and music students and faculty at the BCI. Also, several local soloists presented concerts. Music instruction was offered at the BCI and by two private instructors.[124] The musical life of the village was also enriched by traveling groups that included Brockport on their tours. Almost all were "well attended" or better.

Amusements

Commercial

In addition to the more cultural entertainments described above, Brockporters benefited from a variety of other forms of amusement. Some were commercial entertainments, often touring attractions. One type that was peculiar to the era was the "panorama." These were elaborate visual displays, usually portraying major historical events in the form of murals. Among those visiting Brockport during this period were "Patterson's Panorama on Harper's Ferry," "Panorama of Pilgrim's Progress," a "Polyorama," "Kyle's Colossal Panorama of the Mississippi," and "Barrett's Panorama of the American Revolution."[125, 126, 127, 128, 129] The Hopkins Eidostereon Artistic Exhibit seems to have been similar.[130]

Traveling circuses came through often in the summer. Usually they were combined with menageries. Eleven such visits by eight different circuses were reported in the BR or the VBM during this period. Several other touring shows sound something like circuses. They included the "Yankee Robinson Show" and "Dr. Wilson's Railroad Show."[131, 132]

A variety of other touring entertainment companies visited Brockport during this period. They included a midget on display, some glass blowers, a pair of elk, a troupe of Sioux Indians, the Andrass Marionette Show, magician and ventriloquist Jerome Blitz, two laughing gas demonstrations, "Hambujer, the Great East India Magii," and Tom Thumb and wife.

Probably the greatest diversion for Brockporters was the agricultural fair that was held in Brockport for four or five days every autumn. It ran from 1857 to 1932, with a break from 1869–1877. Its main purpose was to sponsor competition with respect to breeding livestock and all sorts of domestic skills. Also, it included horse racing and, later, automobile and bicycle racing and such entertainments as vaudeville performances, a small circus, band concerts,

clowns, freaks and oddities, movies, trained bears, and trick horses. The grounds also served as the home field for the Brockport Freezers, a semi-professional baseball team.

Private

However, Brockporters were quite capable of entertaining themselves. They had sleighing and skating parties, sometimes skating to Rochester and back.[133] They gathered socially in each other's homes, and they held masquerade balls and went on group "pic nics." The big social event of that period was a grand picnic at the country home of F. P. Root, the leading citizen of the Town of Sweden.[134]

Other notable parties were given by Elias B. Holmes and the Frye brothers. The installation of illuminating gas in his home (now the Morgan-Manning House) gave John C. Ostrom the occasion for a lavish party. The BR reported that the chandelier cost $150 and that the "spaciousness and splendor of Mr. Ostrom's residence is now equaled by but two other residences in the county" and described its owner as "the wealthiest man in the town."[135] He died less than three months later.[136]

Excursions

Brockporters had plenty of nearby commercial venues for "Social Parties" where they dined, wined, and danced. They included Sprague's and Arnold's Inns at Sandy Creek, Randolph and Clark's Hotel and the A. P. Clark Hotel in Clarkson, J. B. French's Inn and R. Lyman's Hotel at Redman Corners, J. P. Nelson's in Clarendon, G. A. Dauchy's in Hamlin, Charles Callow's hotel in East Clarkson, and the Union Hotel in the village itself. The annual Independence Balls at Sprague's and French's were summer highlights. Other occasions for such "balls" were harvest time and Washington's birthday.

A favorite social activity combined sleighing, wining, dining, and dancing. Sprague's yearly New Year's Eve Ball and its Leap Year Party in 1864 were popular destinations on those occasions. Also, a late January outing became a Brockport tradition. Sixty Brockporters made that excursion in 1861.[137] The BR described the 1862 version this way:[138]

> A party composed of about seventy persons, of whom about two-thirds were ladies ... took a sleigh ride last evening to Spencerport. It has been customary for those citizens of this village who fraternize in "head and heels" to have a sleigh ride annually.... The main portion of the party left this village ... about 6½ o'clock, and after an hour's ride through the picturesque and salubrious villages of Cooley's Basin, Adams Basin, and some other basins not unknown to fame, arrived at the point of destination. The sleighing was fine, and the ride delightful, the sleighs apparently running easier for the light-heartedness of their occupants.

The disembarkment took place, when the effects of packing were easily discernable in the ladies' apparel, "round as a hoop" having become as "square as a brick." The gentlemen having doffed their outer garments, and the ladies assumed their usual rotund outlines, a "scraping" of the strings by Prof. Fielding and a companion, in a manner that "kicked up the dance" with the toes, induced the ladies and gentlemen to [enter] ... the Upton House. What occurred in the hall we cannot exactly say; but have a vivid recollection of hearing "all hands round," "down through the middle," &c, often repeated....

About 10 o'clock an excellent supper served up. After supper ... [those] who <u>will</u> dance, again went through the mazy gyrations of waltzes, "hopera," reels, cotillons, &c, for an hour or two longer....

The party arrived home about 2 o'clock this morning, having had emphatically a good time.

Some of Brockport's upper crust traveled further afield for entertainment. Some of them made annual weeklong fishing trips to the Thousand Islands. In July 1860, fourteen of them returned with 350 pickerel weighing 1,200–1,400 pounds, which they distributed throughout the village.[139] A year later, ten of them brought back "a good lot of fish" and "kindly remembered" the BR publisher.[140] In 1862, their big catch was "mostly sold for the benefit of the soldiers."[141] In 1864, they had "a good time," but only "fair success"; nevertheless, they favored Beach "with a fine fish."[142]

Fourth of July

The biggest community celebration some years was the Fourth of July event. In 1860, it was especially elaborate. Planning began more than two months earlier with weekly committee meetings. By the end of May, $280 of the $300 anticipated costs had already been subscribed.

Fifteen of the village's most prominent citizens served on its organizing committees, with Beach as general chair. The day began with a parade starting at 11 a.m. It consisted of "the officers of the day, the orator, invited guests, the cannon, the fire department, Musical Association, and citizens on foot. The procession extended from the canal bridge to College Street, a larger portion of it being citizens on foot."[143] The ceremonies took place on the grounds of the BCI. Two bands played, the church bells rang, a prayer was said, a long oration delivered, and the "Musical Association sang two national odes." The procession reformed at 1 p.m. and marched to the American Hotel for an elaborate dinner for "several hundred" persons. Thirteen programmed toasts and at least as many volunteers were pronounced. However, the planned fireworks were postponed until July 8 due to a rainstorm.[144] No organized celebration was held in 1861, but 199 villagers traveled to Rochester for its program.[145] In 1862, the Fourth of July coincided with the agricultural fair and the festivities, including fireworks,

took place on the fairgrounds.[146] No celebration took place in 1863 or 1864, despite Beach's earnest pleading.[147]

Fires

Fires were a frequent problem in Brockport of the 1860s. The most devastating was the one that destroyed the east side of Main Street from State Street to Market Street in May 1862. It consumed sixteen buildings, including five "of the finest business blocks in the village," seven dwellings, and four barns. Eleven businesses and professional offices occupied the commercial structures. The loss was estimated at $44,565, with about $20,000 worth of insurance coverage.[148]

Other major fires destroyed a flouring mill valued at $11,750;[149] a hardware store with a loss of $13,000–$14,000 and damage of $2,000–$2,200 to two adjacent buildings;[150] a lumber yard and ice house with a loss of $5,000–$6,000;[151] the American Hotel, a blacksmith shop with three apartments, and a dwelling with losses of about $7,000.[152] Sixteen other, smaller fires and two attempts at arson were reported during this period.[153]

The conflagrations were often blamed on arson. The May 1862 disaster was among them. So were the flouring mill, lumber yard, American Hotel, and a small fire in the Silliman, Bro. & Co. plant.[154]

One reason for the heavy losses from those fires was the poor condition of the fire department. The BR complained constantly about the gross inadequacy of the equipment and the tardiness and ineptness of the firemen. It said that "our village fire apparatus is equivalent to no apparatus" being a "wheezy, dilapidated apology for a … fire engine," and despite the "will and muscular ardis of the stalworth men … nary a drop of water could be coaxed … through the valves and orifices" of the pumper.[155, 156] Repairs in the spring of 1861 improved its performance, but availed little in the May 1862 fire.[157]

Accidents

Accidents were another problem plaguing Brockporters in the 1860s. Those who believe that traffic accidents began with the automobile will be surprised by the situation in the village during this period. Runaway horses were the most common cause of mishaps on the roads and streets. The BR reported twenty instances. Also, horses were involved in twelve other accidents. Brockport had 130 horses, some of which were plow horses or race horses and, therefore, not used for transportation. Thus, 1860–1864 Brockport had about one vehicular accident for every 3.6 vehicles. Also, six industrial accidents were reported in 1865.

Then, too, the canal and the rail line that provided such benefits to the village were not unmixed blessings. The BR reported three drownings and three near drownings in the canal. Also, a man fell from the canal bridge and was killed, another was injured by a fall through that bridge, and a young woman skating on the canal was hit by a sleigh and injured. Two persons were injured by a derailment near the BCI, ten sheep were killed by a locomotive, and a man was hurt by a fall from a train.

Crime

The 1865 census reported that, because of the war, "there is less" crime in Brockport. However, the village was no crime-free paradise. In 1860, nineteen prisoners were committed to the county penitentiary from Brockport.[158] Similar statistics were not reported for the other years.

The most serious crime reported in the BR during this fifty-seven-month period was a murder that followed a barroom brawl.[159] Also, the body of a baby was found in the canal about a mile west of the village. Its feet "were tied together with a cord, and the body wrapped up in an old cloth" so "it was generally believed here that the child was intentionally drowned."[160] A mother and her baby died in a botched abortion.[161] Also, in the category of serious crimes were the sixteen burglaries, thirteen of them committed between January 1863 and April 1864.

Much more frequent were charges of drunkenness, though their numbers declined precipitously. This may have reflected reality or been simply a lapse of attention by the BR. It seems unlikely that the decline from twenty-one allegations of drunkenness in 1860 to ten in 1861, zero in 1862, four in 1863, and one in the first nine months of 1864 came about because Brockporters suddenly became abstemious. However, assault and battery cases followed a similar trend, down from eight in 1860 to five in 1861, one each in 1862 and 1863, and three in 1864. Perhaps the dispatch of so many young men to the Union Army accounted for the sharp drop.

Fighting and disorderly conduct were the charges in eighteen cases, but the most common offense in 1860s Brockport, by far, was thievery: fifty-four cases of theft in various forms having been reported. The objects stolen ranged from $4,518 in a bank robbery to "a pair of pantaloons."[162, 163] The items most frequently stolen were clothing and horses. Twelve horses were reported stolen during this period, often with harnesses and buggies. Other stolen livestock included chickens, geese, turkeys, and honey bees.

Other offenses reported by the BR included prostitution. Two prostitutes, a "woman of bad character" and another of "unquestionably bad character," were sent to the penitentiary.[164] Also, two men were arrested for disrupting

religious services.[165] There were at least two cases of counterfeiting and one each of "stuffing the ballot boxes" and abandoning a child.[166] The local jails could not have been very secure, for there were at least six escapes during this period.[167]

A disproportionate number of Irish names appeared on the police blotter. However, the village elite were occasional offenders also. Among those charged with assaults were Levi Pease, a prominent merchant and property-owner, Joseph Sharpstene, the owner of the American Hotel (twice), and Levi Cooley Jr., partner in a planing mill.[168, 169, 170] Sharpstene was also found guilty of passing counterfeit bills.[171] Thomas Cornes, a leading businessman and president of the village board of trustees for several years, and his partner were fined $50 for selling intoxicating liquors without a license.[172] Also, Cornes sued another business man, won, and then had the judgment reversed.[173] Cornes's son, Wallace, was accused of a rape during a camp meeting. He denied it publicly, but then committed suicide.[174] Earlier, young Cornes had become a local celebrity for walking across the canal on a tight-rope stretched between two hotels, in imitation of Blondin's feat at Niagara Falls.[175] Finally, H. J. Thomas, attorney, lost a suit alleging that he was negligent in a legal matter.[176]

2
Leaders

Many of the modernizing activities described in the pages below required considerable effort by Brockporters. In some cases, those efforts required effective leadership. Fortunately, the village included a number of residents who filled that bill. This chapter provides profiles of some of them.

Dayton S. Morgan

Dayton S. Morgan was one of Brockport's most distinguished residents and, certainly, its wealthiest. His company contributed to the modernization of the village in various ways. For one thing, it was at the forefront of the drive to modernize agriculture through the application of machinery. More importantly for the village, it was a major element in its economy and, therefore, a vital support for the modernization activities.

Morgan was descended from a distinguished New England family and his wife, Susan Joslyn, was a member of equally notable New Jersey family. She was related to Jonathan Dayton, a Revolutionary War general for whom Dayton, Ohio, is named.

Morgan was born in the town of Ogden in 1819. His mother died soon after his birth and his father, suffering financial troubles, decamped to Ohio, leaving seventeen-year-old Dayton in the care of an aunt in Brockport. Thus, Morgan was an orphan whose only resources were his talents, energy, and ambition.

He graduated from the Brockport State Normal School and briefly taught school. He contemplated becoming a lawyer, but lacked the means to support himself during the long period of preparation, so he undertook a career in business. He first worked as a clerk in the toll collector's office in Brockport, but soon was employed by a Brockport merchant.

In 1864, while living in a hotel in downtown Brockport, he married Susan Joslyn. The newlyweds rented quarters in what is now the Morgan-Manning

House. Morgan bought the house in 1868, which remained in the family until a 1964 fire damaged it severely and caused the death of Morgan's daughter, Sarah Morgan Manning.

Morgan's industry as a store clerk caught the attention of William H. Seymour, who invited him to join in founding the Globe Iron Works foundry in 1844. Thus, Morgan was the junior partner in the firm, re-named Seymour & Morgan Co.

In 1875, Seymour retired from the company, which was reorganized as D. S. Morgan & Co. Apparently Morgan was an organizational genius. An Australian geographer called Morgan a "remarkable" manager of a far-flung industrial enterprise. At a time of serious impediments to rapid transportation and communication, Morgan managed successfully an enterprise with operations in Brockport, Philadelphia, New York, Chicago, San Francisco, and Europe.[1]

Morgan was also a vice-president of the New York Central Railroad, a founder of Brockport's electric company, an organizer of the Central Crosstown street railway in New York City, chair of the Board of the Brockport State Normal School, and a village trustee. Morgan owned 800 acres that is now part of the city of Chicago. He died in 1890 and left an estate reputed to amount to two million dollars.

The Gordons

Luther Gordon was one of Brockport's most successful businessmen and was also a political leader. He and his son, George, and his three grandsons, Luther, Jr., Fred, and Thomas, contributed in several ways to the modernization of the village. As a banker and as a partner is various business enterprises, Luther contributed importantly to the financing of modernizing activities. His son and grandsons carried on the banking and financing work.

Luther was an exceptionally versatile, enterprising, and successful businessman. He was born in Rushford, NY, in 1822 and entered the business world at nineteen years old as owner of a foundry furnace and the inventor of a plow that he manufactured. He sold that business after a year and a half and pursued the mercantile trade for fourteen years, erecting two buildings to house his two general stores. Meanwhile, he was a livestock broker for sixteen years and entered the lumber business.

In 1856, Luther bought a lumberyard in Brockport and built a steam sawmill and planing mill. He purchased several hundred acres of timber land in Cattaraugus County and 7,000 acres in Michigan. Eventually, he had sawmill operations in East Saginaw and Sterling, Mich., and Holley, Portville, and Olean, NY, and shipped lumber and finished lumber (sashes, doors, ornamental trim, etc.) throughout the east. In the early 1870s, he expanded his business by building several canal boats.

In 1863, Gordon founded the First National Bank of Brockport as its president. It became the leading financial institution in the village and funded various modernization projects. Additionally, he was in the construction business. Most notably, he built his own home across South Street from the Morgan-Manning house, the First National Bank building on the corner of Main and King Streets, the homes that are now the Roxbury and the Webster Funeral Home, the houses along Gordon Street, and the First Baptist Church.

Luther was also prominent in the community's political life, serving as village mayor in 1861 and 1872 and town supervisor in 1868. He died in March 1881. He succeeded in the foundry, mercantile, livestock, lumber, planing, construction, and banking businesses and was a civic leader—quite a record!

Luther and his wife, Florilla, had one son, George, who became his father's business partner and succeeded him. Besides the lumber business and the First National Bank, George was president of the Brockport Building & Loan Assn. and trustee of the Fidelity Trust Company in Buffalo. He and his wife, Ida, had five sons, four of whom survived childhood. Luther, George, and Thomas followed their father as bankers.

The third generation of Gordons were pioneer automobile owners in the village and thereby helped to popularize that modernizing form of transportation. Luther, Jr., however, contributed to the impression of automobiles as dangerous by being involved in three of the early car accidents.

In 1927, the Gordons demolished Luther, Sr.'s, 1873 bank building and erected the present structure. The lumber business and the bank failed in the early years of the Great Depression of the 1930s. The manager of the lumber business, W. E. B. Stull, however, continued in that trade by establishing Stull Lumber and Hardware on Park Avenue, now owned and managed by his grandson, Bill.

George and Ida Gordon owned a five-bedroom cottage on 3 acres of land in the then-thriving lakeside resort of Troutberg. They had a tennis court, a large picnic house, and a boathouse for two boats. The arrival of the Gordons was a major event in Troutberg, as described in Mary Smith's *Remembering Hamlin* book: "Old timers fondly recalled the sight and sound of the Gordon tally-ho, with the uniformed driver of 4 horses up front and the footman at the rear, sounding blasts on his bugle."[2] That was also a familiar sight in the village, as described by Ray Tuttle: the Gordon's carriage, "passing through the streets, loaded with guests, and tended by bright uniformed coachmen, footmen, and accompanied by a bugler provided one of the thrills for the pedestrians of that day."[3] I believe that the Gordon's tally-ho (bugle) is now above the fireplace in the dining room of the Morgan-Manning house.

Thomas and his wife, Ruth, lived very opulent lives with nannies for their children, a cook, a maid, a chauffeur, gardeners, and a carpenter. Dinner, as

described by Thomas's son, in one of Eunice Chesnut's books, included finger bowls, imported lace tablecloths, and sparkling polished silver. Thomas owned three automobiles, including a limousine.[4] Their estate on the corner of North Main Street and West Avenue included greenhouses where Thomas pursued his horticultural hobby. They later became Rogers Florists.

George, Jr., was vice-president of the bank and president of the Brockport Piano Co. Fred married an heiress, was a gentleman farmer, and built Whitehall, a nine-bedroom mansion in Clarkson.

Quite a family—through three generations.

William H. Seymour

The Seymours were, probably, Brockport's most distinguished family in the nineteenth century, from the time James partnered with Hiel Brockway in laying out the village in 1822 until William's death in 1903 at the age of 101. As the senior partner in the foundry that manufactured the first reapers, Seymour played a crucial role in introducing the Industrial Revolution to agriculture, certainly a very important step in the modernization of agriculture, though that occurred well before the period covered by this study.

Horatio Seymour, a first cousin of James and William, was a Civil War governor of New York and Democratic candidate for U.S. President in 1868. Another first cousin was on the New York State Canal Commission while the canal was under construction. Eight Seymours have been members of the U.S. Congress. The first of the American Seymours arrived in Connecticut in 1639.

William Henry Seymour, younger brother of James, was born in Litchfield, Conn., in 1802. He joined his brother at his store in Murray Four Corners in 1818 and moved with him to Brockport in 1822. When James relocated to Rochester in 1826, William took over the store and succeeded him as postmaster.

William was very active politically. He was an ardent Jacksonian, one of the three members of the Central Committee of the local party, and one of its delegates to Monroe County conventions of Republican Young Men. In 1832, he was elected a village trustee and he also served on the Board of Health.

In the early 1830s, he made his first foray into the foundry business as a partner in the Backus & Ganson foundry, which manufactured threshing machines. In 1844, he co-founded the Globe Iron Works to manufacture stoves and agricultural implements. A year later, Cyrus McCormick came to Brockport and hired the firm of Backus and Fitch to manufacture 100 of his reapers. The result was a failure: either they did not produce the machines or the reapers did not work. McCormick then hired Seymour & Morgan to produce 100 reapers and they worked.

When Seymour retired from the firm in 1875, he went into business with his son, Henry, who had moved to Sault Ste. Marie, Mich. in 1873. Henry shipped timber to his father, who operated a lumber mill in Brockport.

In 1836, William married Narcissa "Nancy" Pixley, who had come to Brockport in 1820 to become the first school mistress in the village. She was the niece of Peletiah Rogers, an early merchant and a relative of the Seymours. In 1823, Rogers had built the house at 49 State Street that now houses the village court and the Emily Knapp Museum. He had built it in the style of a Dutch row house. Upon his marriage, William bought the Rogers home and lived there the rest of his long life. He remodeled it extensively, giving it a very different appearance. In the 1860s, he added the mansard roof.

After retiring from business in 1882, Seymour continued to lead an active life. He traveled to Europe on a five-week trip at age eighty-one and again at age eighty-six. At ninety-two years, he spent most of the summer in Chicago, visiting the Columbian Exhibition nearly every day. At the age of 100, the whole village celebrated his birthday and he took a ride in Brockport's first automobile. He remained in good health until three weeks before his death in October 1903 at age 101.

Henry Seymour

Henry W. Seymour, though less known to Brockporters, also had a distinguished career. He was probably the most influential leader in the effort to bring the normal school to Brockport, one of the aspects of the modernization of the village discussed in the pages below.

Seymour was born in Brockport in 1834, the son of William. He attended Brockport schools, the Brockport Collegiate Institute, Williams College, and Albany Law School where he passed the bar, but never practiced law. In 1852, he opened a factory manufacturing reapers, rotary pumps, and engines, directly across the street from his father's reaper factory.

Henry was also active in local politics, serving three terms on the village board in the late 1860s. He and Thomas Cornes were perhaps the most active advocates in the campaign to secure the normal school for the village and he served on its board. Early in the Civil War, he was active in recruiting efforts in the village, but, though the very eligible age of twenty-six, he never entered the armed forces. In 1873, he moved to Sault Ste. Marie, Mich., where he built a sawmill and planing mill, farmed, and resumed manufacturing reapers and other farm implements. He was vice-president of the First National Bank, president of the St. Mary's Water-Power Co., and shipped timber to his father.

He was a very busy man in Michigan, for he pursued political as well as business interests. He served in the state House of Representatives, 1880–82,

and the state senate, 1882–84 and 1886–88. In February 1888, he was elected to an unexpired term in the U.S. House of Representatives, but served only until March 1889. He was not re-elected in 1872. He died on a trip to Washington in 1906.

Wilson Moore

Another distinguished Brockport family was that of Wilson Henry Moore. Moore was born in Clarkson in April 1859, the son and grandson of Clarkson farmers, and attended the Brockport Normal School. Already as a boy, he showed business enterprise by obtaining a Kelsey hand press and printing and selling business and calling cards. In 1878, at age nineteen, he founded the Moore Subscription Agency based on the "clubbing" concept, whereby subscribers received discounts by ordering several magazines at once. One obituary claimed that "by means of that plan he did more than any other man to bring good reading to the homes of our land."[5]

In 1882, he moved his company to King Street in Brockport and, when that building burned in 1888, to the vacant former office building of D. S. Morgan & Co. on Market Street. He expanded the business by buying two Chicago magazine agencies. His business was so successful that it became the world's largest subscription agency, mailing one million of its catalogs annually, and had 100 employees. Its business alone raised the Brockport post office from fourth class to second class.

In 1888, he and his cousin, Manley Shafer, acquired the bankrupt Ham-Rogers Shoe factory that was housed in another former D. S. Morgan building on Market Street. They expanded it and built the brick building near the railroad on Park Avenue that burned in 1974. The shoe business thrived, producing high-end ladies' shoes for nationwide distribution and had 400 employees.

Moore was also a partner with F. F. Capen in the Capen Piano Co. and with Gifford Morgan in the Rochester Wheel Works. He served on the Normal School Board and was a founder of the Brockport Rural Cemetery Assn. and a vestryman at St. Luke's Episcopal Church. He owned the first automobile in Brockport.

In 1887, he married May Scranton, a Brockport woman. They had two children, Henry Wilson and Helen. About that time, he built a house at 39 State Street. Although his business successes helped finance the modernization of Brockport, he also opposed modernizing its transportation means when he fought the proposed street railway that would have passed in front of his home.

After his death, his widow sold the subscription business to the Cottrell Agency in North Cohocton and it continued as the Moore-Cottrell agency until 1974, using the clubbing concept that Moore had invented nearly a century

earlier. She lived on in Brockport with her two children until her death in 1949. Helen married one of her father's employees, Stanley H. Geerer, and owned the family home until she died in 1981.

Henry was drafted in 1917 and served in the field artillery. He was an officer in the Moore-Shafer Shoe Manufacturing Co. until it failed in 1927. After that, Henry was a traveling cigar salesman.

Henry married in 1919. He and his wife, Marian, were avid and quite successful amateur golfers. They took annual cruises to the Caribbean and South America. After Marian's death in the early 1960s, Henry and Helen lived in the same nursing home, but had become estranged and would not speak to one another. Reportedly, he had suffered from bouts of mental illness since childhood. Neither Helen nor Henry had any children.

Wilson has no descendants. All of his businesses have failed. None of the buildings they erected still stand. Only the house he built on State Street and the flagpole he raised in front of the Moore-Shafer Shoe Co. remain as the legacy of a man who was once perhaps the most enterprising businessman in Brockport history.

George Barnett

George F. Barnett may well be one of the great, unsung heroes as an inventor. As shop foreman at the Seymour & Morgan foundry, he was probably instrumental in solving the problem of manufacturing a workable reaper with all the implications for the modernization of agriculture.

Barnett was born in Oneida County in 1804 and moved to Brockport in 1826. In his early life, he was an architect and carpenter. According to a contemporary source, he was employed by Cyrus McCormick from 1840 to 1845 to help him perfect his reaper. In 1845, he became plant superintendent of the Globe Iron Works that later became Seymour & Morgan.

The basis for calling him a great inventor arises from what seems to have been his role in making possible the production of successful reapers. In fourteen years, McCormick had been unable to solve the problem of manufacturing his reaper in quantity. Nor had he devised a way for the operator of his reaper to ride on the machine: either the seat would unbalance the machine or get in the way of the reel. Those problems were solved by Seymour & Morgan.

It is unclear who in the firm actually deserves the credit for that accomplishment. It may have been a team effort, but, as Barnett was in charge of that work as the plant superintendent, he was probably its principal contributor. As the reaper was the first successful farm machine, Barnett may well be credited with bringing the Industrial Revolution to the world's agriculture, one of the most important developments of the nineteenth century.

In 1850, Seymour & Morgan stopped producing the Barnett machine and he left their employ and joined George F. Whiteside in founding a rival farm implement manufacturing firm. They acquired the property where Hiel Brockway's boatyard and brickyard had burned in 1848 and constructed the building that still exists at 60 Clinton Street. In 1886, Whiteside died, Barnett retired, and the factory closed. Their buildings later housed, in succession, a flour mill, a lumberyard, a fruit packing plant, a farm implement dealership, and an automobile repair shop.

Barnett was also actively politically, first as a Whig and then as a Republican. He served as a village trustee in 1833. Religiously, he was a leading member of the Presbyterian church. He built the house that still stands at 26 State Street. He had married in 1828 and had three children. Barnett died in 1897 at the age of ninety-three and is buried in the High Street cemetery.

Byron Huntley and Samuel Johnston

Huntley and Johnston were leaders in the farm implement manufacturing industry in Brockport that was a major element in the economy of the village during the period of its modernization. Not only did the manufacturing industry contribute importantly to the financing of the various modernizing activities, but its introduction was itself a major modernizing step.

Huntley was born in the town of Mexico, Oswego County, in 1825, the son of a doctor of Scottish birth. In 1844, he enrolled in the Brockport Collegiate Institute, but dropped out because of ill health. He later attended Madison (now Colgate) University in Hamilton, NY. He returned to Brockport as a clerk in the Fitch, Barry & Co. foundry that, under earlier ownership, had produced the first, unsuccessful McCormick reapers. In 1850, he became a partner in that firm, which evolved through partnership and name changes into the Johnston Harvester Co. by 1868, after Samuel Johnston became a partner and company president with Huntley as secretary-treasurer.

Johnston was born in Shelby, Orleans County, in 1835 and began a career as an inventor of agricultural machinery before the age of twenty-one, patenting many devices over many years. Perhaps Johnston's most notable invention was the first reaper that could cut and handle all kinds of grain. He worked for farm implement manufacturers in Buffalo and Syracuse before coming to Brockport. Apparently he was less a business manager than an inventor for he resigned as president of Johnston Harvester Co. in 1875 and formed Samuel Johnston & Co., which seems to have been a vehicle for his inventing, patenting, and licensing agricultural devices. His last patent was issued only days before he died. He died in 1911 and is buried in Lakeview Cemetery.

The Johnston Harvester Co. occupied a factory on North Main Street that was reputed to be the largest manufacturing plant in Monroe County at one

time. In the early 1880s, it encountered labor troubles and the factory burned in June 1882, perhaps as a result of arson. Following the fire, the company moved to Batavia because of its location on two main rail lines, but probably also to avoid the troublesome Brockport workers.

Huntley was a businessman, not an inventor. He served as company president from 1875 until his death in 1906, but was, above all, a salesman. His greatest feat was introducing American farm machinery to the European market. He traveled to Europe annually from 1870 until he suffered a disabling stroke in 1902. He was made a Chevalier of the Legion of Honor by the President of France for his services to French agriculture.

Huntley was founder and sponsor of the Brockport Fire Department's Byron E. Huntley Steamer Co., which existed from 1877 until 1910 and was a crucial part of the modernization of firefighting in Brockport. Ironically, it was housed in one of the Johnston Harvester Co. buildings that burned.

Huntley died in 1906 and is buried in a family plot in a Cleveland, O., cemetery. He never married and had no direct survivors. His estate was estimated at $440,000– $920,000, an enormous amount in 1906. Among the beneficiaries was the First Baptist Church of Brockport, which received $2,000. Five fire companies in Batavia received $800 each, but the Byron E. Huntley Steamer Co. received nothing.

The Johnston Harvester Co. was acquired by the Canadian farm implement manufacturer Massey-Harris in 1910 and continued in operation until 1958.

Horatio N. Beach

Horatio N. Beach is best remembered as the founder and publisher of *The Brockport Republic*, but he had a far larger impact on Brockport than that suggests. He was one of the most active promoters and supporters of the various modernizing activities.

Beach was born in Greene County, New York, in 1826, but his family moved to Bridgeport, Conn., when he was a boy. His father was a merchant and Horatio succeeded to the business at his father's death in 1847.

Local newspapers and committees were essential elements in the organization of American national political parties after the innovations by Martin Van Buren on behalf of Andrew Jackson in the late 1820s. After the Republican Party began to emerge in 1854, its leaders undertook to pull together such a network. Beach seems to have moved to Brockport in October 1856 for the purpose of founding a newspaper to support the candidacy of John C. Fremont, the first Republican presidential candidate.

In his first issue, Beach announced, "Our paper will be REPUBLICAN in politics, [but] we do not intend to make politics the leading object of our paper."

He retired as publisher in favor of his son, Lorenzo, in June 1871, but remained its political editor and continued in active association with the paper until six days before his death.

Beach was also active in business. He organized the Brockport Businessmen's Association and was its first president. He initiated the formation of the Brockport Union Agricultural Society that ran a fair in Brockport for many years and was its secretary. He was also founding secretary of the Brockport Electric Company and one of the founders of the Brockport Gas Light Co., the Brockport Piano Manufacturing Co., the Moore-Shafer Shoe Manufacturing Co., and a fruit cannery. He engaged in real estate development and home building in the area of Beach Street. There was hardly a major business activity in Brockport that did not have his imprint.

He was also a mover and shaker in community affairs. He established and ran for many years Brockport's first free book lending library. He was the founding secretary of a farmer's club and secretary of two fraternal lodges. He organized the Brockport Rural Cemetery Association and spearheaded the drive to build the Soldiers' Memorial tower. He was also a Toll Collector for the canal and a trustee of the Brockport Collegiate Institute.

Politically, he was a leader of the Republican Party locally and in the county. Diplomatically, he was a United States Consul in Mexico, Venezuela, and Ecuador.

The *Republic* had been joined in the newspaper business in Brockport by the *Brockport Democrat*, another weekly, in 1870. The two papers competed for fifty-five years, before they merged as *The Brockport Republic-Democrat* in 1925. That paper continued until 1972, when Ken Hovey retired. Andrew Wolf took it over as the *Brockport Post* for a few more years. Beach's legacy to this village had continued for about 120 years.

Beach died on September 21, 1896—exactly forty years after his arrival in Brockport. Throughout that long residency here, he was a pillar of the community.

Merritt and Milo Cleveland

The Clevelands played an important role in the modernization of the village. Their construction company built the portion of the reconstructed canal in the Town of Sweden. This modernization of the canal to convert from animal power to mechanical power had an important effect on the economy of the village.

The Clevelands were a distinguished family of civil engineers. Merritt was born in 1849, the son of a Jefferson County farmer. He began his career as a civil engineer in 1870 at age twenty-one and already by 1872 he was in charge of constructing the Lake Ontario Shore Railroad. His later projects included

building part of the Canadian Pacific Railroad in Canada's Northwest, major portions of the Welland and Murray canals in Canada, the Toronto harbor, and the north channel of the St. Lawrence River.

Other railroads that he built were the Pittsburgh, Cleveland, and Toledo Railroad in Pennsylvania and Ohio, which became part of the Baltimore and Ohio system, and the Kingston & Pembroke Railroad in Canada.

Merritt and his family, including five-year-old Milo, re-moved to Brockport in 1884. In 1888, he had the contract for paving Brockport's Main Street. He built the house just east of the Newman Oratory and Milo built the large white house across the street from it. Milo attended Brockport schools and the Brockport Normal School.

Merritt's last project was the construction of the Town of Sweden section of the rebuilt canal and the locks at Waterford in 1912. He died on May 23, 1912, before those projects were completed.

After his father's death, Milo took over the company, completed those projects and, in 1913–14 built the locks, dams, and bridge on the Seneca River. I have been unable to learn if the company continued after that. Milo served as vice-president of the First National Bank until its failure in the 1930s. While he was the bank's vice-president, he defeated Thomas Gordon, the bank's president, for village trustee, 57:55. He served until 1922, but did not seek re-election, nor did Thomas Gordon. Milo died in 1954.

Thomas Cornes

Thomas Cornes's role in the modernization of the village was most prominent through his leadership in the effort to establish the normal school there. Additionally, he presided over the village board and the town board during much of their involvement in various modernization projects.

Cornes was one of Brockport's most prominent citizens, but is largely forgotten today. He was born in England in 1813 and emigrated with his family to New York's Madison County in 1827. In 1834, he removed to Brockport, where he spent the rest of his life, living at 26 Union Street.

Cornes was a butcher by trade, invested heavily in real estate, and was very active in public life. He was co-owner of the largest meat market in Brockport and owned a large complex of buildings on the east side of the village that served as a slaughterhouse. He also owned three farms, five stores on Main Street, a warehouse on the canal, a distillery, a retail plaster shop, and several dwellings. He and his son, Charles, held a patent for a refrigeration device.

Cornes probably holds Brockport's record for the number of times he was elected to municipal boards. He was elected to the village council seven times and served as its president for five of those years. He was elected Town of

Sweden supervisor three times. He was frequently a delegate to various political party conventions. His political success is the more remarkable in that he was a Jeffersonian Democrat at a time that the village and town were heavily Republican. By one account, he was the leading Democrat on the west side of the county.

He was appointed to political patronage jobs, canal toll collector in the 1850s and during the Civil War, and manager of the Western House of Refuge in Rochester, a home for orphan and wayward boys.

He was also active in other civic affairs. He was on the boards of the Brockport Collegiate Institute and the State Normal School. He shared with Henry Seymour the credit for having the greatest influence in bringing the Normal School to Brockport. He was Treasurer of the Brockport Union Agricultural Society that operated the local fair. He was an active firefighter and one of the original fire companies in the village was named for him. During the Civil War, he was among the most active leaders in the various efforts to support the war.

Cornes was also very litigious. He frequently protested his property assessments, refused to pay his taxes, and intimidated the village collector. He had raucous quarrels with his neighbors over trees, sidewalks, sewers, and election bets. During one such dispute, a neighbor commented that he "never knew a case before where Mr. Cornes had nothing to say." On one occasion, he brought a number of serious charges against a canal superintendent, all of which were dismissed. He sued another business man, won, then had the judgment reversed. Also, he and his partner were fined $50 for selling intoxicating liquors without a license. He engaged in a long-running feud with Horatio Beach, publisher of *The Brockport Republic*. When things did not go his way in the Democratic Party, he supported Republicans.

Thomas Cornes died on December 20, 1878 at the age of sixty-five.

3
Infrastructure

Municipal Water

Securing a modern, adequate, safe, and reliable municipal water system for the village required the most difficult, arduous, and protracted effort in the history of the village government. Until 1890, Brockporters had relied on private wells and rainwater collected in cisterns for their needs. As the 1880s progressed, however, they became concerned that "much of the well water was not fit to drink." They were also aware that some neighboring municipalities had developed municipal water systems. They set about to do likewise. The issue quickly became "the all-absorbing theme" of political life in the village.

In the 1880s, the village dipped a cautious toe into the water business by hiring "Mr. Payson's" Brockport-Holley Water Co. to pump water from the canal for street sprinkling and fire protection. Brockporters demanded the sprinkling because of the dust stirred up from the dirt streets during warm weather.

As to the possibility of a more extensive water system, *The Brockport Republic* reported that "an extensive examination of the country south of here" in a search for water had been made "years ago [by] a wealthy capitalist.… But the search was fruitless." The first step in the renewed effort for a full-blown water system was an April 1887 survey of the village by an engineer from the Buffalo firm of Bassett Bros. that "make[s] a business of supplying villages with force-water." It operated by contracting with municipalities to supply water for fire protection and for a franchise to sell water to private customers.

In early May 1887, Mr. Bassett appeared before the village board and suggested that the village install a system with water to be drawn from wells. He said that it could buy such a system at a cost of "about $75,000 provided a water supply could be procured nearby" or it could enter "into a contract with some properly organized company." He estimated that the fire protection with seventy-five hydrants in the village would cost about $3,000 a year and that private customers would pay from $4 to $12 a year.

In a second appearance a week later, Mr. Bassett told the village board that a "good, thoroughly built system of waterworks" would make the village more attractive to manufacturers and would lead to a decrease in fire insurance rates of 8 to 20 percent. Besides the pipes in the village and leading to it from the source, the system would require a standpipe and pumping station.

When Mr. Bassett made a third appearance before the board, "There was a good attendance of citizens." A Mr. F. S. Pecke of Watertown also appeared and offered to submit a proposal. The village clerk warned that, if the waterworks furnished water for flush toilets, "the refuse would be carried into the present [storm] sewers which are not at all adapted to the purpose." Flush toilets had so recently become available that Mr. Bassett confessed that "It was the first time he had heard [the issue] raised."

The trustees also visited Albion to see how its system worked. In a referendum on May 24, Brockport's voters decided by 206:8 that they did not want "To bond the town and own the works" and by 151:140 that they did not want "To rent waterworks." The trustees believed that the double vote was confusing, so they called a second referendum. This time, the only question was whether the voters wanted to rent a system. It carried, 161:54.

The trustees called for bids and received three. Choosing among them, according to the board President, had become "the question of the hour." The offer by Brown Bros. was rejected 6:0, but the board deadlocked on choosing between Hanover & Morgan and Bassett Bros. They voted 3:3 on each one four times. Finally, at a board meeting in mid-July, Hanover & Morgan withdrew its offer and the board accepted that of the Bassett Bros.

On August 26, four months after the issue was first raised, the village board signed a detailed contract with Bassett Bros. No adequate supply of well water was found south of Brockport, so wells in Clarendon, 5 miles away, were developed. This meant that the same source could supply a system for Holley as well as Brockport. The difficulty in finding a suitable source delayed the project. Not until June 1890 were the pipes in the village being laid by a fifty-man crew, mostly Italian.

By late August, fifty orders for private hook-ups had been placed. Finally, on November 7, 1890, the village board accepted the waterworks, agreeing to pay $2,650 a year for service to the fire hydrants. A total of 7½ miles of pipe had been laid in the village, two wells with 30-foot diameters had been drilled, and a pumping station and standpipe had been built in Clarendon. Three and a half years after the effort began, Brockport finally had a municipal water system. However, that was by no means the end of Brockport's struggle for a safe and reliable municipal water system.

The 1890 system served Brockport well for thirteen years, but the installation of a sanitary sewer system in 1903 overtaxed it. Already in 1905, the problem was serious. The existing system produced 220,000 gallons daily and Brockport needed at least twice as much.

The village board tackled the problem and negotiated a contract with the Rochester and Lake Ontario Water Co. to furnish water for "domestic and sanitary uses and for fire protection, flushing sewers, sprinkling and manufacturing purposes." Private consumers were to pay from 25 cents to 30 cents per 1,000 gallons, depending on volume of usage. Water was to be provided "without charge for domestic and sanitary purposes, in the Public Building, Public Schools, Parochial Schools, two drinking troughs for beasts and one drinking fountain for men."

However, the agreement was contingent upon the R. & L. O. Water Co. purchasing the existing, inadequate system from the Brockport-Holley Co. They were not able to agree on a purchase price and the deal fell through. The village then explored several alternative solutions. The R. & L. O. Water Co. offered to allow the village to extend water lines the 16 miles to another of its facilities and tap into that source, but the board did not find that satisfactory because of the cost.

An engineer hired by the Water Committee reported that an adequate water supply could be secured in Clarendon with additional wells. The Brockport-Holley Co. refused to undertake that investment, unless it could raise its water rates, which the village refused to allow. They did drill three test wells, but found only contaminated water. Also, they pleaded lack of the means to build a system to draw water from Lake Ontario. The board spent over $1,500 to "drill test wells south of the village," but that proved fruitless. It considered the use of water from the Erie Canal, but rejected that because that the water was likely to be badly contaminated.

On February 25, 1907, the village board appointed a five-member committee "to investigate the water question." At the request of the committee, the village board appointed an engineer "to make a detailed investigation and estimate of the cost of a system extending to the Lake." However, they rejected its $325,000 plan for such a system as beyond the financial capability of the municipality.

At the recommendation of the Water Committee, the village board invited representatives of ten neighboring municipalities along the canal to meet in Brockport to explore the possibility that "a solution of the problem of an adequate supply might be worked out more cheaply and more satisfactorily to all concerned if co-operation among these villages and cities can be secured." No report of such a meeting, if it occurred, was ever published.

Meanwhile, the situation was becoming more desperate. To increase the volume of water available, the Brockport-Holley Co. added creek water to its well water. However, a chemical and bacteriological analysis of the result showed "the presence of the *Bacillus Coli Communis* and allied intestinal organisms in large numbers" and concluded that "the water is unsafe for drinking purposes." Brockporters were advised to boil all drinking water. The village health officer reported that the village had four cases of typhoid, implying that they had been caused by the contaminated water.

By August 1912, all other options seemed to have been exhausted and the village offered to buy from the Brockport-Holley Co. the Brockport portion of its system, but the parties could not agree on a price. The village offered $60,000, but the company asked $90,000. The board then bit the bullet and proposed petitioning the State Conservation Commission for permission to build a "new water plant to Lake Ontario." That plan was approved by the voters in a referendum, 407:32. Anticipating Commission approval, the board took an option on a piece of lakeshore land for the filtration basins and pumping station and planned to build a reservoir on Beach Ridge, a mile south of the village that would be 130 feet in diameter, 16 feet deep, and have a capacity of 1.5 million gallons. Additionally, it began securing rights-of-way for a pipeline across properties from Hamlin to Brockport.

On September 27, 1912, the Commission began four days of formal hearings on the petition. It took sworn testimony from thirty witnesses. The report of the hearings in the *Republic* consumed some 370 column inches of space, more than it ever devoted to a single event in its 115-year history.

Village Attorney John D. Burns submitted the village's plans and maps, and he described in detail the inadequacies of the present situation. He said that, since 1903, "the company has been totally unable to furnish all the water needed. Only once in the past three years has the Company been able to keep the pressure up to that required and that lasted only … less than a quarter [hour?].… During the night there is no water at all.… There is no water by which to flush closets [toilets]." The company was not providing enough pressure for fire protection and insurance rates had been "raised anywhere from twenty five to one hundred percent." Industries were unable to continue their operations. Such water as is available "is found to be extremely inferior quality there being an accumulation of muck and sediment." The company had agreed to provide canal water for sprinkling purposes, but had diverted it to a factory "not only for operating purposes but for drinking purposes," despite it being "not much better than a sewage dilute." The village's sanitary sewer system had ceased to function because of the water shortage. The real estate market was moribund. In short, the failure of the water system had become a major catastrophe for the village.

Representatives of the Water Company refused to consider any more exploration for well water and proposed, either that the village use canal water or wait until completion of "the proposed plant at Lyndonville … [which] will be able to furnish all of the towns of western New York with an ample supply of water." Neither solution was acceptable to the village. Most of the other testimony dealt with the practicality and suitability of the Lake Ontario solution.

On December 17, 1912, four months after submitting its petition and one month after the conclusion of the hearings, the village board received word that its application had been approved with a few modifications. The *Republic*

reported that "everybody" was "excited" and that "The people of Brockport have much to be thankful for."

At its December 20 meeting, the board instructed the village clerk to advertise the sale of the waterworks bonds, and a week later, it authorized publication of a request for proposals for construction of the system. On January 10, the board awarded the bonds in the amount of $750,000 and agreed to purchase land for the site of the reservoir. On January 29, it awarded the construction contracts. After a struggle that had dragged on for nearly a decade, things were finally moving very quickly.

By referendum, on May 13, 1913, the voters approved (148:6) the purchase of the Brockport portions of the Brockport-Holley Co. water system, and in another referendum on December 22, they voted to authorize an additional $12,000 of bonds "for the purpose of finishing the waterworks system."

On January 14, 1914, the first Lake Ontario water reached the village. The effort to provide a safe, reliable municipal water system that had begun in 1887 finally ended, twenty-seven years later. The *Republic* prophesized that "we are now being served from a source that is not expected to run out for centuries to come." A century later, this prediction holds true.

Municipal Sewers

Early Brockport lacked both storm and sanitary sewers. At least some of the streets had parallel ditches to channel water runoff, a rudimentary storm sewer system. The first step in the process of obtaining storm sewers for the village came in 1864 when the village charter was amended to include this provision:

> The trustees of said village ... may cause sewers and culverts to be constructed therein, upon application in writing of two-thirds of the property owners on said street or highway residing in said village, and the cost and improvements made under this section shall be assessed upon the real estates in said village, benefited by the improvements in proportion to the benefits resulting thereto.

The charter amendment did not distinguish between storm sewers and sanitary sewers, though only storm sewers may have been intended because it made no mention of a disposal plant. In any case, the matter of storm sewers seems to have been solved with little difficulty. They were gradually added, often by covering over the ditches with tile. This was done by the village government at the request and expense of the property owners. At least so far as *The Brockport Republic* was concerned, the development of a storm sewer system attracted very little attention and aroused no controversy.

The establishment of Brockport's sanitary sewer system came about through a very different process and involved a lot of controversy. It was very much a result of popular demand, against the wishes of the government of the day. In fact, it led to the overthrow of the incumbent majority and the election of a village board more sensitive to the wishes of the residents.

The first step toward the creation of a sanitary sewer system was taken by a group of forty residents who petitioned the village board in December 1901 to submit "to the vote of the electors" a proposition "that there be established and maintained a permanent sewer system ... to embrace the entire village together with a proper and sufficient sewage disposal system." The petitioners estimated the cost of such a system at no more than $75,000.

Village President Delbert A. Adams "recommended that the petition be denied" because the village charter did not authorize such a referendum, leaving the authority to decide such an issue with the trustees. Additionally, he opposed the proposed expenditure, saying "that he would not sign any paper placing a bonded indebtedness on the village" and that "if the people vote for such indebtedness they must elect some other person to act as the president of the village." The "Committee of Citizens" that had submitted the petition also presented a memorandum with the request that it be read and filed. The trustees read and filed the memorandum and tabled the petition until the next meeting. The memorandum is not in the village's records. The board never took any action on the petition.

The petitioners got their revenge and a sewer system through the normal democratic electoral process. The "Committee of Citizens" seems to have led a campaign to "throw the rascals out" and replace them by men more favorably inclined to the sewer proposal. Emery J. LeBarron, who was a member of the Adams party, but was absent for the December vote, was defeated for re-election in the election the following March. Adams's name was on the ballot, but on March 5, he made a statement to the board, describing some aspects of the village's condition. He summed up by saying that "the village is immensely prosperous, is in good sanitary condition, with many new stores and sidewalks, and a population of over 4,000 people." Then he concluded by alleging that "many people prefer to have more village money expended and a higher tax rate, and so after 12 o'clock at noon, on Monday, March 24, 1902, another person will be village president."

His prediction was accurate. On May 18, the voters re-elected Luther Gordon (unopposed 677 votes) and Julius L. Heinrich (442), who had favored the petitioners, and defeated Adams (266) and his running mates, LeBarron (281) and Myers Young (232). They were joined by Thomas Berry, Trustee (403), and John W. Cunningham, President (414). John F. Dailey, Addison Palmer, and William R. Blossom were holdover trustees who had opposed the petitioners in December. The balance on the board had changed from 4:3

against the petitioners to 4:3 in favor. LeBarron had been absent from the December vote.

In a post-election article, the *Republic* reported that the 697 voters was the largest number in the history of the village. It commented that the "heavy vote for the opposition was unquestionably greatly increased by the refusal of the Adams party to submit to the people, in December, the question whether the village should bond itself for a sewerage system."

Another factor in the outcome of the election may have been the influence of the Normal School. One of the speakers at the dedication of a new wing to the Normal School building said that "the establishment of an adequate system of sewers was one of the duties which the village owed to the school, and expressed the earnest hope that the duty would soon be discharged."

At his inaugural meeting as President, Cunningham said that the main issue in the election was "not the sewer question", but "whether or not six men could manage the affairs of the village without any regard to the wishes of the people, simply ignoring the petition of the taxpayers and thus deprive them of their sovereign rights."

In the new political climate, the "Committee of Citizens" presented another petition in April 1902, asking again that a proposition "that a sewer system by established and maintained by the Village of Brockport" costing between $65,000 and $75,000 of borrowed money be submitted to a special election. Theodore S. Dean, a lawyer, appeared before the board in behalf of the committee. The board adopted the proposed resolution (4:3). The negative votes were cast by the holdover trustees. The proposition was approved in the referendum (298:121).

At the June 2 board meeting, the trustees received a draft contract giving the proposed specifications for the sewage system and ordered 100 copies to be printed. A request for proposals was issued and six bids were received. The estimated costs ranged from $63,403.36 to $73,150. The contract was awarded to Holahan and Kearns of Rochester for $65,595.61. Heinrich and Gordon, who had been so supportive of the petitioners, now joined Blossom in voting "nay," both on this issue and on the appointment of a supervising engineer. The trustees then approved by voice vote the issuance of $75,000 in bonds.

Simply agreeing to the construction of the sewer system and providing for its financing did not relieve the board of its burden. It was frequently called upon to make more decisions. The construction contract had included a completion date of June 1, 1903. However, on June 1, Thomas Holahan appeared before the board and asked that the time for completion be extended by "about three months" for the sewers and "about five months" for the disposal plant. The board never acted on that request, but did agree to pay the supervising engineer for the additional time he required. On June 5, 1903, the board agreed to pay $350 for a set of plans for the disposal plant. On June 23, it had to rule on a request to call a public hearing

on a proposal to change the location of the disposal plant. They had to deal with complaints about the limits of the extent of the system. They had to approve the prices to be paid for the materials for the construction of the disposal plant.

Although there seems never to have been a formal announcement of the completion of the system, by the end of 1903, the board was no longer dealing with matters related to the construction of the system. The last notice taken of the project was an announcement that the village treasurer had received from Assemblyman John Pallace, Jr., a draft for $14,278.13, an appropriation of the State of New York "for the purpose of aiding the village in the construction of is sewer system". Pallace was a Brockport attorney.

Brockport had now entered the Modern Age with a modern sanitary sewer system, a prime example of bottom-up political decision making. Left to the village board, it might never have taken the plunge. Every step of the way, the board was divided on the broad question and most of the details. Members of the public intervened frequently to influence the decisions.

Modernized Streets

When Hiel Brockway and James Seymour laid out the village in 1822, they used a map by Zenas Case, Jr., which included streets from Clinton Street to Adams Street. Those streets were very primitive. The surface was dirt, muddy when it rained, dusty when it did not. They had no paving, no sidewalks, no lighting, no storm sewers, and no street signs or house numbers.

When the village was incorporated in 1829, among the powers conferred on the village board by its charter were "the building and maintaining of streets … the providing of street lighting." In 1838, charter amendments were enacted, including a 700-word chapter on the highway department. It authorized the trustees to appoint "one or more street commissioners" and regulated the system for Brockporters to pay or work off their road taxes.

The charter was amended again in 1864 in the manner described in the section on charter amendments in the introductory chapter above. The committee mentioned in that section proposed amendments authorizing the trustees to "cause any street or highway … or any which may hereafter by laid out, or opened and used … to be graded, levelled, paved, macadamized, or graveled … upon application in writing of two-thirds of the property owners on said street or highway … and the cost and improvements made under this section shall be assessed upon the real estate in said village, benefited by the improvements, in proportion to the benefits resulting therefrom." The amendment did not mention cobblestones explicitly, but "paved" may have referred to them. That provision carried in the meeting by 34:32 and was included in the amendments approved by the state legislature.

In fact, the 1864 amendments seem only to have confirmed what the village was doing already, at least with respect to the business section of Main Street. In August 1856, the trustees paid "A Robt. G. & A. B. McConnell to continue the paving of Main St. to the corner of State St. for $550." Though the record does not show the kind of paving, the fact that they paid "F. Hellrantz—for Sand and stone used in repairing Main Street in August last 2.00" suggests that it was then that the cobblestone paving was done. The cobblestones would have been laid on a bed of sand.

At least the cobblestones had been laid by 1876, for, on June 1 of that year, *The Brockport Republic* reported that a buggy had upset on Main Street because the "cobblestone would not allow the wheel to slip and hence the vehicle was thrown over on its side with a great crash." That the cobblestones had been there for some time before 1880 is suggested by an item reprinted in the *Republic* in June 1880 from the Le Roy Courier that referred to Brockport:

> Your rough and ungainly cobblestone Main street pavement is a relic of the past and should be relegated to the waste places of mother earth. No people as civilized and happy as yours ought to be in their many advantages, should be shaken out of their senses over a highway which would disgrace a Caffre [an insulting and offensive term for any African-American] mud hovel or a Zulu bark wigwam.

Neither the village board minutes nor *The Brockport Republic* ever suggests that Market Street was also paved with cobblestones. Yet, a photo postcard from the period between 1906 and about 1910 clearly shows that Market Street and Main Street had the same paving.

That the editor of the *Republic* was not enamored of the cobblestones is suggested by his willingness to publish that slur on his village without disapproving of it. Yet, despite the apparent dissatisfaction with the cobblestones, the village was very slow in finding a solution.

The issue of Main Street's paving next arose in the *Republic* in July 1907, during the construction of the Rochester, Lockport, and Buffalo trolley line. The editor commented that "The brick paving at the union of State and Main Street show 'what might have been' the whole length of State and Erie Streets." That model of the brick paving used in conjunction with the laying of the trolley tracks suggested the desirability of more of the same. That suggestion was given additional force by reports that nearby towns, such as Medina were getting brick paving.

The matter finally came to a head in May 1912, thirty-six years after the first report in the *Republic* of problems with the cobblestones. The state was going to run a main highway through the village on Main Street and villagers were urging that the occasion be used to get brick paving to replace what the

Republic called "the ancient mess of cobblestones." The *Republic* reported that the state would pave only a 16-foot width and the village would be responsible for the other 40 feet. On September 23, the board adopted a resolution asking the State Commission of Highways to lay brick pavement in the business district and agreeing to pay for an additional 40 feet of width beyond the highway's 16 feet. At the September 30 meeting of the board, it was reported that "the petition of the Village of Brockport for a brick pavement had been received" by the State Highway Commission.

Then, in November, the village board called a special election to vote on the proposition: "Shall the Village of Brockport construct a brick pavement on Main street from the south side of the canal bridge to the brick pavement on State Street" with the cost to the village of $7,900 to be raised by bonds that would be retired through property tax receipts. At the December 2 referendum, the proposition carried (94:17) with two spoiled ballots.

That would seem to have gotten the ball rolling. However, another twenty-five months passed before any further action was reported. Then, on December 1, 1914, President Harmon reported to the village board "that Messrs. Miller & Kidder from the office of the State Highway Department visited the village ... with a plan for the construction [of] a brick pavement through the business section of Main Street." The board was not pleased that Main Street would not be paved the whole length. It complained that "other places have been given 16 foot brick pavement running through their entire length" and voted to defer improvement of the business section until the board could "use every effort to obtain from the State a 16 foot brick pavement on North Main Street and on Main Street from the [trolley] tracks south to the village limits."

At the March 29, 1915, meeting of the village board, a communication was received from the state highway commissioner inviting the village to send a representative to Albany for an April 6 meeting "to discuss matters regarding the construction of Route 30 through this village." Board President Harmon reported back to the board on April 12 that, at the Albany meeting, he had asked that the state pave the entire length of Main Street with brick. In reply, the Commissioner stated:

> ... that he would guarantee the village as good a pavement through its entire length as lead up to it on West Avenue, in addition to the brick pavement already agreed upon in the business section. He stated further that he might be able to give us the brick pavement instead of the concrete outside of the business section. He said he would bear in mind the wishes of the village and do his best to satisfy them at an early date.

Harmon and Trustee Luther Gordon traveled to Albany again in July 1915 and returned with the message that Highway Commissioner Duffy had told them

that "the improvement of the business section of Main Street would be put under way at once but nothing for the north or south ends could be included in this contract." By August the contract for the Main Street work had been let to Morrison & Quinn, Inc., of Rochester for $10,827.65 and the contractor "will be allowed to crush the old stone block which is the present pavement on this street" to use for the "course aggregate of the concrete foundation" for the bricks.

The next step was to order "the A. L Swett E[lectric]. L[ight] a[nd] P[ower]. Co., the Postal Telegraph and Cable Co., the Western Union Telegraph Co., and the New York Telephone Co. ... to remove all poles, wires and appurtenances owned, maintained or controlled by them ... above the surface of the business section of Main Street" to prepare for the reconstruction.

Then, on August 16, the board received a petition from the property owners in the business district asking for that portion of Main Street to "be curbed wholly at the expense of the owners of adjoining lands." The board called a public hearing for August 30 at which no one objected, so the board passed a resolution ordering those property owners to construct, by October 1, at their expense, curbing "in accordance with plans and specifications prepared and on file in the office of the Commission of Highways." However, on October 14, the *Republic* reported that the board had found that the "Ohio sandstone ... curbing which is being distributed ... is not satisfactory" and that "Medina sandstone ... will be acceptable."

On September 2, 1915, the *Republic* reported that "Work was begun Monday of clearing Main Street of the pavement stones and property owners" were told to "see that their water pipes are practically new in order that no tearing up of the street later will be necessary." The *Republic* also assumed that the "village will undoubtedly see that the gas mains and feeders are put in proper shape for the same reason."

No further progress was reported until, on May 16, 1916, the board received a bill from the state highway department in the amount of $8,686.15 to cover the cost of the brick pavement on the 40-foot-wide portion of Main Street for which the village was responsible. The village's street fund had a balance of $8,796.13.

Now that the paving was complete, the final step in the modernization of the business section of Main Street was the construction or repair of the sidewalks. On May 16, the board ordered the property owners to pay for that work, requiring that it be done under the supervision of the street commissioner and be completed within ten days after the owners received notice. It identified thirty-six properties requiring new sidewalks and ten requiring repair. The least expensive was $4.95. The most expensive was $61.40—the Methodist church.

Thus, the cobblestones had served Main Street for sixty years and had done so for forty years after the first report of problems with them. The bricks would do the same for less than thirty years, being replaced by asphalt in 1945.

That took care of the business section of Main Street, but what about Brockport's many other streets? At the same time that the brick paving was laid in the business section, the state improved a 16-foot width of the rest of Main Street and North Main Street with bituminous macadam—pavement made of layers of compacted broken stone bound with tar. That seems to have been the case with other village streets. Mayor Harmon in his annual address of March 1917 said: "By the method which was adopted several years ago of building a street or part of a street every year or two, this Village is now said to have the best system of streets of any place of its size in Western New York, or perhaps New York State." By "building" streets, he seems to have meant macadamizing them.

The public record does not indicate the nature of the improvement of the streets, but in at least one article in the *Republic* "macadamized" is mentioned. That seems to have been the standard for improving streets at that time. Postcards from that period seem to show macadamized streets.

Though the village took the responsibility for doing the paving and assuming the cost, it required the owners of the abutting properties to install the curbing at their expense. For instance, at the village board meeting of May 13, 1912, the "property owners of Holley street from Main street to the Forks and Adams street from Main street to Chappell street" were ordered "to lay curb and water table in front of their property." At the same time, the Brockport-Holley Water Company and Brockport Gas Light Company were ordered to "make all connection to all houses and vacant lots on" the same streets. This seems to have been the standard procedure as all village streets were gradually macadamized and curbed.

During the time that the village was struggling with its efforts to modernize the surfaces of its streets and the curbs and sidewalks along them, it also worked on modernizing their lighting. The system in use at the outset of that period, the 1880s, was kerosene lamps and the village paid someone to light them each evening and extinguish the flames each morning.

In 1883, electric street lighting had first been used in Roselle, NJ. By November 1884, this invention had received enough attention that *The Brockport Republic* opined that "Brockport must soon have electric lighting." Yet four months later, the *Republic* reported that "A gentleman called at Brockport the other day to talk about lighting the streets with electricity. The cost would only be $9,000 a year, but it was concluded that we would get along with gas, kerosene, and moonlight awhile longer."

In December 1887, George D. Morgan, eldest son of D. S. Morgan, secured a franchise from the village board "for the right and privilege to erect poles in the streets of the Village of Brockport with wires thereon for the purpose of transmitting electricity to be used for lighting, heating, and motive power, the same to be granted for the term of fifty years." Once the resolution had passed,

Above: This plant produced illuminating gas for the village from 1859 until about 1930.

Right: Fannie Barrier Williams was born in Brockport in 1855 and was the first African-American graduate of the State Normal School. Later, she became a civil rights leader in the Midwest.

Village Report.

Annual Report of the Trustees of the Village of Brockport, April 7th, 1868.

The Trustees have received during the past year the sum of $1,625.52, as follows—

Cash of late Treasurer,	$147.66
" Collector and Poll Taxes,	1,169.41
" Burying Ground Lots,	240.00
" Licenses,	42.95
" Village Hall Rent,	25.50
	$1,625.52

The Trustees have expended the sum of $1,612,92, as follows—

For Gas,	$228.91
Burying Ground,	59.05
Assessing,	52.95
Clerk's Salary,	50.00
Fire Department,	46.06
Lamp Repairs,	34.87
Police Services (last year)	26.50
Village Hall Repairs,	14.45
Insurance,	10.50
Lock-up,	4.50
Office Expenses,	1.16
Miscellaneous,	9.92
	$538.87

And for street work as follows—

For Main Street,	$256.23
Cleaning and Scraping streets,	146.16
Lyman Street,	76.79
State Street,	74.33
Gravel,	64.45
Town Line Road,	61.62
Gordon Street,	55.53
Holley "	43.65
Clinton "	34.50
Bridge approaches,	31.75
Fayette Street,	31.00
Erie "	28.81
Clark "	22.30
Market "	15.61
Main street Alley,	15.00
Frazer Street,	13.49
Mechanic "	13.40
Perry "	13.05
Union "	12.80
Spring "	11.55
Monroe "	10.50
Water "	9.50
Ware House Alley,	8.63
Utica Street,	5.75
Liberty "	5.25
King "	5.15
North "	3.15
Merchant "	1.75
Adams "	1.00
College "	1.00
South "	1.00
Queen "	.50
	1,074.05
Amount brought down,	538.87
	1,612.92
Balance in hands of Treasurer,	12.60
	$1,625.52

NORMAL SCHOOL REPORT.

The Trustees have received during the past year on account of Normal School Fund the sum of $16,334.93, as follows—

Cash of Collector,	$9,330.43
" Bonds,	7,000.00
" Lime sold,	4.50
	$16,334.93

The Trustees have expended the sum of $14,407.22, as follows—

For L. R. Robbins, to apply on contr't,	$11,022.01
Repairs to Gymnasium, Fences and Walks,	799.64
Interest,	816.22
Apparatus and Furnishing,	573.16
School Seats,	393.50
Architect,	225.00
Legal Expenses,	130.00
Painting Roof,	119.95
Freight and Express on Books,	119.27
Insurance,	72.51
Work on Excavations and cisterns,	34.25
Advertising,	34.15
Paid Mr. Barlow for Estimates,	30.00
Water Tanks,	29.00
Freight on School Seats,	25.22
Printing,	20.75
Plowing and Seeding Garden,	20.00
Sheriff's and Clerk's Fees,	19.39
Trucking,	13.30
Extending Taxes,	10.00
	$14,497.22
Balance in hands of Treasurer,	1,927.71
	$16,334.93

Statement of outstanding Normal School Bonds.

No.	To Whom Payable.	Am't.	Due.
1	University of Rochester,	$3,000.00	Jan. 1, 1875
2	do. do.	3,000.00	Jan. 1, 1876
3	do. do.	4,000.00	Jan. 1, 1877
4	James Brown,	2,000.00	Jan. 1, 1870
5-10	M. McVicar,	1,182.54	Jan. 1, 1869
12	G. W. Hildreth & Co.,	393.50	April 17, 1868
14-40	Luther Gordon and others,	7,000.00	Aug. 15, 1868
		$20,576.04	

Statement of liabilities of the village to be provided for during the official year, commencing April, 1868.

Bonds, Nos. 5 to 10 inclusive, Due Jan. 1, 1869,	$1,182.54
Interest on same,	82.78
Bond No. 12, Due April 17, 1868,	392.50
Interest on same,	22.95
Bonds, Nos. 15 to 40 inclusive, Due Aug. 15, 1868,	7,000.00
Interest on same	340.04
Amount to Contractor,	12,977.99
Interest on Bonds Nos. 1 to 4, Due Jan. 1, 1869,	840.00
	$22,839.80

UNPAID TAXES OF 1867.

The following Normal School Taxes were returned uncollected by the Collector:

Mary Gordon, (bank stock)	$13.80
O. B. Minkler,	13.50
Hiram Root,	5.25
J. A. Field,	7.50
	$40.05

All of which is respectfully submitted.

THOMAS CORNES,
HENRY W. SEYMOUR,
EDGAR BENEDICT,
LUCIUS T. UNDERHILL,
LAFAYETTE SILLIMAN,
DANIEL HOLMES, Village Clerk. Trustees.
April 7, 1868.

The Village Trustees submitted this annual budget for the year 1867-68 and the Normal School Trustees reported to the Village Trustees.

Brockport's railroad passenger depot in the early 20th century.

Brockport's railroad freight depot in the same period.

The original Roman Catholic Church on the corner of Erie and Utica Streets in 1911. The house in which Fannie Barrier Williams was born is to its right.

The First Presbyterian Church on State Street with the "manse", residence for the pastor, to the left and Wilson Moore's house beyond.

Above left: Susan B. Anthony, women's rights leader, spoke in Brockport at least three times.

Above right: Horace Greeley, renowned journalist and Democratic candidate for President in 1872, spoke in Brockport. This portrait is by John H. Kent, who did business in Brockport for 18 years before he partnered with George Eastman in founding the Eastman Kodak Co.

Below: Brockport hosted an agricultural fair from 1857 to 1869 and from 1877 until 1932. This photo is from 1912.

Above: A massive fire destroyed most of the buildings on the east side of Main Street between Market Street and State Street in May 1862. Most of the structures in this photo replace the ones burned.

Left: This marble bust and oil painting of Dayton S. Morgan are in the home that he and his descendants owned from 1868 until 1964 and is now the seat of the Western Monroe Historical Society.

Above: An early 20th century photo of the home that Dayton S Morgan owned from 1868 until his death in 1890.

Below: Portraits of Luther Gordon, "lumber king", political leader, and banker, and his wife, Florilla Cooley Gordon.

Luther Gordon's home on the corner of Main and South Streets.

Luther Gordon's lumber yard on east State Street.

Above: The First Baptist Church that Luther Gordon built in 1864. It is still in use, though much changed.

Below: "Whitehall", Clarkson home of Fred Gordon, gentleman farmer and grandson of Luther Gordon.

Left: Henry W. Seymour, son of William H. Seymour, State Normal School advocate who was elected to the House of Representatives after moving to Michigan.

Below: The building that housed Henry W. Seymour's reaper factory, directly across the street from his father's reaper factory.

Right: Wilson H. Moore, founder of the Moore Subscription Agency and the Moore-Shafer Shoe Manufacturing Co.

Below: The Moore-Shafer Shoe Manufacturing Co. plant on Park Avenue. It once employed 400 workers.

Left: George F. Barnett, shop foreman at the Seymour & Morgan foundry and partner in the Whiteside & Barnett Agricultural Works.

Below: The Whiteside & Barnett farm implement factory on Clinton Street. The building still stands.

Above: George F. Barnett's home at 26 State Street.

Right: Byron E. Huntley, co-founder of the Johnston Harvester Co.

The Johnston Harvester Co. plant on North Main Street.

Workers at the Johnston Harvester Co.

Above left: Horatio N. Beach, publisher of the *Brockport Republic* and a business and political leader.

Above right: Merritt Cleveland, owner of the Cleveland & Sons construction company that built railroads and canals in several states and Canada.

Below: Merritt Cleveland's home on Adams Street. His son and successor, Milo, built a large home across the street.

Above: Thomas Cornes's home on Union Street.

Below: The Lake Ontario pumping station for the Brockport water system.

NOTICE TO CONTRACTORS

Brockport, N. Y., Sewage Disposal Works.

Sealed proposals will be received by the Board of Trustees of the Village of Brockport, N. Y., until eight (8) o'clock, P. M., on the 17th day of September, 1915, for the construction of a disposal works to consist of a two story sedimentation tank, sprinkling filters, sludge drying bed and final settling basin with outlets and appurtenances.

Plans may be seen and specifications obtained at the office of the Village Clerk, at Brockport, or at the office of Charles C. Hopkins, engineer, 349 Cutler Building, Rochester, N. Y.

The Board reserves the right to accept or reject any proposal, to contract with other than the lowest bidder, or to reject any or all proposals and advertise again, as in its judgment may be for the best interests of the village.

A certified check made payable to the order of James Brennan, Village Treasurer, to the amount of $1,000.00 must be deposited by the bidder and accompany his bid as a guarantee that in case the contract is awarded him, he will, within seven days after notification of award, execute the contract.

Bids must be sealed and addressed to George B. Harmon, Village President, Brockport, N. Y., and marked on the outside of the enclosing envelope, "Proposal for Brockport Sewage Disposal Works."

Dated, August 27th, 1915.

 GEORGE B. HARMON,
 Village President.

F. E REYNOLDS,
 Village Clerk. 3w

Building the disposal plant for Brockport's sanitary sewer system.

Cobblestone paving at the intersection of Market and Main Streets.

Macadam paving at the south end of Main Street.

SIDE-WALK ORDINANCES.

It hereby ordained by the Trustees of the Village of Brockport, that the plank side walk on the streets hereinafter named, be thoroughly repaired or rebuilt, or new walks be enacted by the owners or occupants of lots adjoing said walks; that the same be repaired, built or constructed in a good and workmanlike manner under the superintendence of the Trustees or Street Commissioner; that the same be made to correspond in width with the walks already on said streets and to be graded as directed by said Trustees, and be rebuilt, repaired or constructed with lumber not less than one-fourth inches thick, laid crosswise and be completed within twenty days after notice of this ordinance shall be served on the owner or occupants of said lots respectively.

It is further ordained that all new walks hereafter built on the north side of College street be not less than five feet four inches in width and in other respects as above provided. And it was further ordained that new plank walks be constructed on the south side of Lyman street and on the east side of Gordon street, opposite premises owned or occupied by the persons hereinafter mentioned, by the owners or occupants of lands adjoining said walks, that the width of the walks on Lyman street be three feet and on Gordon street four feet; that the same be constructed in a good and workmanlike manner, under the superintendence of the Trustees or Street Commissioner, with lumber not less than one and one-fourth inches thick, laid cross-wise, and on such grade as may be directed by the Trustees, and that the same be completed within twenty days after notice of this ordinance shall be served on each owner or occupant of said lots respectively.

And it is also hereby ordained by said Trustees that the brick side walks on Main street as hereinafter specified be repaired or relaid by the respective owner cr occupant of lots adjoining the same, in a good and workmanlike manner, under the superintendence of the Trustees or Street Commissioner, and within twenty days from the service of this ordinance as hereinbefore provided.

Whoever shall neglect or refuse to comply with any of the provisions of this ordinance shall forfeit and pay to and for the use of said Trustees a penalty of Twenty-five dollars.

The following are the streets and premises above referred to:

REPAIRS.

Holley street, north side, opposite premises owned or occupied by J. D. Spring, L. T. Underhill, A. N. Braman, J. Welch, C. Osgood, C. Veazie, J. S. Ford, and W. H. Fuller.

Holley street, south side, S. F. Parker.

South street, south side, L. Gordon, Mr. Graves.

South street, north side, J. O. Guild, S. M. Andrews, M. O. Randall.

Mechanic street, west side, John Maul, M. Fosmire, M. O. Randall.

Mechanic street, east side, D. Paine, J. A. Field.

Main street, east side, Martin Coats, C. A. Bolt, Mrs. Hankerson, J. O. Guild, G. Benson.

Main street, west side, L. G. Wilder, L. B. Courtney, M. Randolph, W. Randolph, W. H. Bunn, J. A. Sleaster.

Fayette street, east side, L. Coy, S. Howard, A. B. Sprague, D. Toaz, E. G. Wood, Mr. Wilson.

Fayette street, west side, C. O. Secor, J. Dolph, Polly Veazie, C. A. Pease, J. Lester.

Liberty street, north side, C. O. Secor, D. Burroughs, Mrs. Osburn, J. Welch, J. Burroughs.

Clark street, south side, P. Mehan, S. Goff.

Market street, north side, G. Richards, J. S. Bridgeman.

Market street, south side, Mrs. Lyman, J. Harrison.

Water street, north side, J. A. Latta, C. Weyburn, H. C. Davis.

Water street, south side, M. French.

Clinton street, north side, W. E. Johnson, E. Greenough, Mrs. Hill, I. Barnes.

Clinton street, south side, Mrs. Kingsbury.

Utica street, east side, Mrs. Sanford, A. Chappell, St. Mary's Roman Catholic Church, J. D. Spring.

Utica street, west side, F. Motley, W. B. Rich, Mrs. Sadler, Mrs. Wickes, West District School lot, C. Walter, J. Doyle.

Erie street, north side, W. Tripp, J. W. Adams, Mrs. Avery, T. & A. Frye.

Erie street, south side, J. W. Adams, Mrs. Sadler, S. M. Ashley, D. Carpenter.

King street, North side, Freewill Baptist Church, D. M. L. Rollin, H. D. Cowles.

King street, south side, W. L. King.

Monroe street, north side, G. Barnes, A. Harmon, F. Haight.

Union street, north side, E. Hart, S. Patterson.

Union street, south side, J. Smith, H. Belden, C. Webb, P. Brennan.

High street, north side, M. French, T. Leary, Mrs. Smith, J. Ryckman, Mrs. Harvey.

Spring street, south side, R. Smith.

State street, south side, (new walk) L. Gordon, T. Cornes,

State street, north side, L. Gordon, E. Colby, E. Baker.

State street, south side, R. Paine, G. H. Allen, St. Luke's Church.

Adams street, North side, L. G. Wilcox, J. W. Burroughs, J. Blackstock, Mrs. Guenther, P. S. Wilson.

North street, east side, J. Blackstock, T McKeon, F. Fosbender, E. Morrison, J. D. Stafford.

College street, north side, J. Doyle, Spaulding & Greenough, J. W. Dimmick, W. H. Benedict, R. Thacher.

College street, south side, W. Morrison, C. M. Brockway.

BRICK WALKS.

Main street, east side, J. Harrison, J. M. Bowman, A. Harmon, T. Cornes, J. A. Latta, J. Minot.

Main street, west side, Mrs. Dr. Carpenter.

NEW WALKS.

Lyman street, south side, William Green, Richard Bendle, Wm. Kincaid, James Monroe, John Gleason, James Gleason, Michael Gleason, Patrick Shaw, John Slaven, Geo. Hoffman, John Bulger, Edgar Holmes, Charles Hilbert, George Diver.

Gordon street, east side, Luther Gordon, R. W. Millard, James Sloan, Wm. L. Page, A. L. Adams.

D. HOLMES, Village Clerk.

Sidewalk ordinances, part of the Village Trustees futile efforts to improve Brockport's wooden sidewalks.

Brockport's electricity generating plant on the south bank of the canal between the Main Street and Smith Street bridges.

Brockport mail carriers in 1911 after the introduction of home delivery.

Cleveland and Son's machinery at work rebuilding the canal in the Town of Sweden in 1914-15.

The canal in Brockport after it was rebuilt to accommodate power-driven craft.

SEXTUPLET, WHICH DEFEATED THE EMPIRE STATE EXPRESS TO BE EXHIBITED AT THE TOURNAMENT HERE ON SATURDAY NEXT.

A BICYCLE TOURNAMENT

Which will be One of the Most Extensive Ever Seen in Western New York — Magnificent Prizes—Famous Riders—Saturday, Aug. 29.

We take pleasure in calling attention to the grand bicycle tournament to be held on the fair grounds in Brockport the coming Saturday. Neither pains nor expense have been spared to make it *the* event of the season in Western New York, and that there will be crowds in Brockport to witness the grand events no one questions.

This is a home enterprise, which all will help along with pleasure and pride.

The road race—a fifteen mile run—will take place at ten o'clock in the morning and the track events at the driving park will commence at two o'clock, sharp. The Sextuplet will call out a large crowd of people to see the wonderful machine, while

Local Politics.

The Republican county convention for the nomination of candidates for county offices will be held next week Saturday.

The Republican Congressional convention in this district will be held two weeks from to-day.

The nominations by the Republican State convention of Frank S. Black, of Troy, for Governor, and Timothy E. Woodruff, of Brooklyn, for Lieut. Governor, is very generally satisfactory to the Republicans of this section, and will prove a strong ticket.

William J. Bryan, the Democratic nominee for President, made an address in Rochester yesterday. Brockport was represented in the list of vice presidents by John Owens, James E. Conley, Fred. Schlosser, Jr., and John W. Cunningham. Other nearby representatives were George I. Rich, Henry Allen, Richard Spurr, Albert Gallup, Gustavus Dauchy, Charles B Preston and William M. Clark.

Publicity in the *Brockport Republic* for a bicycle tournament in Brockport, part of the Village's participation in the "bicycle rage' of the 1890s.

Brockport's first automobile in 1902 with its owner, Wilson Moore, and William H. Seymour's on Seymour's 100th birthday.

A Buffalo, Lockport & Rochester Railway Co. trolley on State Street about 1910.

PROPOSALS
FOR THE ERECTION OF STATE NORMAL SCHOOL BUILDI[NG]
AT BROCKPORT, N. Y.

Sealed Proposals for the erection of the State Normal Sc[hool] Buildings, at Brockport, according to the plans and specifications of Levi Cooley Architect of the building, will be received by the Trustees of the Village of Broc[kport] at the Office of the undersigned, in Brockport, until the 15th day of June next. [The] plans, specifications, and full particulars in regard to the same, may be seen a[t the] Office of the Clerk of the Village.

Proposals are desired for the erection and completion of [the] whole buildings according to the plans and specifications; and also separate prop[osals] for the enclosing of the buildings according to plans and specifications for that p[art] of the work; and also for the erection of each wing separately.

The Trustees will reserve the right to accept or reject an[y or] all of the proposals received.

By Order of the Trustees.

D. HOLMES, Village Clerk

BROCKPORT, MAY 20, 1867.

Above: The Brockport State Normal School about 1900.

Top: Building a wing on the State Normal School

Above: The Grammar School, a "union" elementary school built in 1907 to replace three "district" schools.

Opposite above: The Training School wing of the State Normal School that was added in 1900.

Opposite below: The library in the State Normal School.

SWEDEN.

There have been plenty of times in bygone days when greater interest has been manifested here than there was last Tuesday, and still there was quite a strife over three or four offices. Four persons only, who were not named on the straight Republican ticket, were elected: Mr. Welch as Clerk, Mr. Drake as Justice of the Peace, Mr. Stickney as Highway Commissioner, and Mr. Gartley Collector. The latter, however, is a Republican. Mr. Crippen, Assessor, (chosen by mutual consent) is a Democrat. Pursuant to custom, when Supervisors prove efficient and popular, Mr. Williams was reelected for a second term. The increased majority materially heightens the compliment. The vote received by each candidate was as follows:

For Supervisor—
Frank E. Williams, Republican ... 576
Raphael Cook, Democratic ... 363
Foster Udell, Prohibitionist ... 47
For Town Clerk—
Byron C. Ketcham, r ... 432
E. F. Welch, d ... 475
Frank Consaul, p ... 78
For Collector—
W. H. Patten, r ... 474
James Gartley, r ... 505
For Justice of the Peace, full term—
Theodore S. Dean, r ... 552
Geo. W. Vunk p ... 81
For Justice of the Peace, to fill vacancy—
John Sutphin, r ... 451
John N. Drake, d ... 477
J. E. Mitchell, p ... 89
For Overseer of the Poor—
Charles Mills, r ... 543
Charles H. Scranton, d ... 282
Hugh McLachlan, p ... 56
For Assessor—
Ezekiel H. Crippen, d ... 977
Maurice Starks, p ... 85
For Highway Commissioner—
Elijah W. Young r ... 399
Edwin J. Stickney, d ... 535
M. Willard, p ... 47
For Constables—
W. H. Pollock, r ... 894
Conrad H. Guenther, r ... 881
James Stickney, r ... 574
Charles Fordham, r ... 553
Geo. H. Williams, r ... 588
John Fay, d ... 377
V. D. Banker, d ... 324
Walter Henry, d ... 361
R. Alma, p ... 46
G. Loomis, p ... 47
S. Gage, p ... 47
A. Hoffmeister, p ... 48
L. B. Courtney, p ... 49
For Inspectors of Election, 1st dist—
George I. Brainard, r ... 560
Harris Holmes, r ... 564
Herman Goodrich, d ... 356
Edmund Rowe, d ... 354
P. Bovenizer, p ... 54
A. E. McCullock, p ... 54
For Inspectors of Election, 2d dist—
Patrick Mulhern, r ... 558
George B. Harmon, r ... 558
Daniel Pease, d ... 350
Patrick Donnellan, d ... 353
Charles Irwin, p ... 54
T. J. Waterbury, p ... 54
For Inspectors of Election 3d dist—
Adolph May, r ... 588
Wm J. Edmonds, r ... 565
Simon F. Kettner, d ... 336
James Cotter, Jr. d ... 357
H. D. Chapman, ... 54
A. Tooley, p ... 54
To raise $4000 for Highway Fund—
For ... 407
Against ... 68
To raise $1000 for Poor Fund—
For ... 158
Against ... 15
For Excise Commissioner—
C. Van Epe, (Against License) ... 240
J. W. Larkin, (For License) ... 505

March 21st 1916

The Annual Election in and for the Village of Brockport was held Tuesday March 21st 1916, at the Public Building in said Village.

The polls were opened at One o'clock P.M. and closed at 5 o'clock P.M.

The whole number of ballots cast upon which votes were counted for one or more candidates 168
number of ballots blank
number of ballots spoiled
number of ballots void

The following candidates received the number of votes set opposite their respective names

For President George B. Harmon 142
For Trustees: Thomas C. Gordon 159
 Warren B. Conkling 157
 John H. Welch 154
For Treasurer James Brennan 159
 One year
For Assessor William Conley 159
 Three years

Voting machine No. A.40114 was used for voting, registering and counting the votes cast at said election

On Question No. 1. Motor Fire Truck.

QUESTION NO. 1.
Motor Fire Truck.
"Shall the sum of Two Thousand Dollars ($2,000.00) be raised by tax or assessment for the purpose of purchasing a motor fire truck to be used by the Protective Hose Company No. 1?"

The total number of votes cast upon the above proposition
For the above proposition 105
Against " " 188
Blank 3
Spoiled 105
Proposition number one was declared lost.

Above: A report of the 1916 election results in the Meeting Minutes of the Village of Brockport Board of Trustees.

Left: A report of the 1889 Town of Sweden election results in the *Brockport Republic*.

The Brockport Village Hall and Fire Department with the Moore Subscription Agency in the background.

The Capen Hose Co. No. 4 fire house at Park Avenue and Main Street.

Brockport's first fire truck, a 1914 International.

the Board President said that "Nothing might come from the effort to introduce electric lighting here, but the privilege just granted was one of the necessary preliminary steps."

Morgan used his franchise as the basis for founding the Brockport Electric Co., which held its organizational meeting in June 1888. In November, it contracted with the Thompson-Houston Electric Light Co. of Buffalo to install ten to twelve arc-light dynamos plus sixteen to eighteen incandescent lamps for street lighting in the village at a cost of $2,000 per year. The carbon arc light consisted of an arc between carbon electrodes in air and was widely used starting in the 1870s for street and large building lighting. They were much stronger than incandescent bulbs and, presumably, were to be placed at major intersections. Construction of the generating plant was to begin "at once." By November 8, residents were already complaining that the street lights were too bright, so it seems that that aspect of the modernization of our streets had been accomplished.

Still another aspect of the modernization of Brockport's streets was effected in 1899, when the board contracted with Cornelius C. Flagler to "furnish and place in their positions signs designating the names of the streets of the Village for 16¢ each." Presumably, house numbers were added at the same time.

Cement Sidewalks

One of the most dramatic improvements in the everyday life of the average Brockporter was, surprisingly, the replacement of wooden sidewalks by cement. The wooden sidewalks were a constant, serious problem and required more attention from the village board, year in and year out, than almost any other issue.

According to *The Brockport Republic*, sidewalks in the early decades of the village were built by "the village authorities." However, in scathing criticism, it complained that they had been "doing nothing or doing next to nothing terribly" about the "disgraceful state" of the sidewalks that had been allowed to lapse into "intolerable" condition by the late 1850s.

Those "authorities" seem to have tired of the task and used the adoption of village charter amendments in 1864 to secure the authority to require property owners to build and maintain the sidewalks at their expense, under the supervision and direction of the street commissioner, and in compliance with standards set by the village board and by a set deadline. If they failed to comply, they were subject to a fine.

Under the new charter, the trustees were constantly involved in sidewalk business. They acted on petitions for sidewalk building. They fielded many, many complaints from residents about the deplorable condition of the sidewalks

of their neighbors. If they found the complaints credible, they ordered the street commissioner to take action. They struggled to enforce the levies. They initiated some remedial action themselves. They attempted to resolve disputes over property lines when owners could not agree on where sidewalks should be located.

After that, a group of property owners who wanted a sidewalk on their premises petitioned the board for permission to build one. The signers had to constitute a majority of the owners along that stretch of street. Often, a minority would dispute the request on the grounds that they could not afford the cost or that they would not benefit from it. Usually, the board approved the request.

Though the owners bore the cost and effort of building the sidewalks, the village continued to have a major responsibility for them. The street commissioner would be instructed to grade the bed on which the sidewalk was to be laid: that was a major undertaking. For example, in 1886, the commissioner reported that he had "drawn dirt and sand and graded for nearly 8 miles of sidewalks; and have drawn from the gravel pit and other places more than 5,000 loads of gravel and dirt."

Also, the village continued to be responsible for the crosswalks. In 1886, for instance, the commissioner "built 29 plank crosswalks at a cost of about $300 and 6 stone crosswalks at a cost of $600."

The wooden sidewalks were never regarded as satisfactory. The boards warped, broke, and disappeared, and nails protruded dangerously. As each owner built his or her sidewalk, they were often not on the same grade as the adjoining ones or not properly aligned with them. Sometimes they were built in the street. The *Republic* reported many cases of broken arms, legs, wrists, ribs, shoulders, and hips and sprains and bruises. On one occasion, it complained that "people were falling all over town."

Heavy rains were a special problem. The wooden walks tended to float away from their moorings. Also, walking on them after such a rain was hazardous. Not only were they slippery, but also water sometimes squirted up through the cracks, dousing the unwary pedestrian.

The *Republic* exhausted its vocabulary of negative adjectives in describing the sidewalks over the years. Some of its descriptions were "rotten," "hazardous to life and limb," "very shattered condition," "tumble-down," "sadly in need of repair," "wretched," "very bad shape," "bad shape everywhere," "awful," "intolerable," and "horrible condition."

The commercial district of Main Street and Market Street had brick sidewalks. Also, there were a few brick sidewalks scattered on residential streets. However, the bricks generated almost as many complaints as the wooden ones. In 1887, the village board forbade any new brick sidewalks. Beginning in the 1870s, a few owners laid stone walks, but they were much more expensive than the wooden ones.

Several lawsuits against the village resulted from defective sidewalks. The village claimed that the property owners were responsible for maintaining their sidewalks and that if the village were sued successfully for damages, it would charge the amount back to the property owner. One suit for $1,000 was settled for an undisclosed amount. Another for $5,000 went to trial and was decided in the village's favor.

The village lost two other cases. One cost the village $1,307.08 in damages and the other $2,800, plus lawyers' fees and related expenses. Apparently, the village was unable to charge the costs back to the property owners, for it issued bonds to raise the funds. This required a special election to authorize the bonds and decide the timing of the payments. Eighteen voters opted for payment in three annual notes, two voters said two notes, ten said one note, and two ballots were blank.

In another case that went to trial in 1901, the plaintiff received an award of 6 cents. His petition to appeal was denied. Additionally, in 1911, the village lost a case costing it $2,000 that had gone all the way to the Court of Appeals. The only other lawsuits because of the wooden walks were claims for $5,000 in April 1908 and $3,000 in May 1916. The *Republic* never published their outcomes.

Brockport winters were especially tough on the sidewalks. Every spring from 1864 through 1884, the village trustees inspected all the sidewalks. Beginning in 1885, they delegated this task to the street commissioner. They identified the walks that required repair or replacement. The list was published in the *Republic* with the ordinance requiring the owners to repair or replace.

Some owners did the work before the inspections were done, yet many did not. The number of orders varied greatly from year to year. For instance, in 1890 they numbered 335, but in 1893 and 1899, only forty-two. The average seems to have been about 167.

Later, the commissioner would check to see if the work had been done. If not, the commissioner would do the work and bill the owners. If the owners did not pay, the charge would be added to the owner's property tax bill. That was the theory. In practice, enforcement was quite spotty. The trustees constantly debated how to ensure that the owners complied with the ordinance and the *Republic* harped on their failures.

Salvation came early in the new century in the form of concrete sidewalks. Portland cement, of the sort used in concrete sidewalks, had been in common usage by the 1850s. The first mention in the *Republic* of concrete sidewalks was an item about their appearance in Palmyra, New York, in late 1897. It first reported their arrival in Brockport on May 3, 1900, saying that "many" Brockporters were "putting down cement sidewalks."

In 1906, the village board considered and rejected a request that the village subsidize concrete walks. At the same time, it enacted an ordinance requiring

that all new sidewalks be either cement or stone. In 1908, it adopted an ordinance laying out in great detail the specifications for concrete sidewalks, including the exact proportion of the ingredients to be included.

In 1907, its franchise permitting the Niagara Falls Electrical Transmission Co. to string electric transmission wires in the village required that it reimburse property owners along Clark Street from Smith Street to Main Street and the full length of Barry Street one half the cost of laying concrete walks.

Gradually, concrete and stone replaced the unlamented wooden walks throughout the village. In July 1907, the *Republic* boasted gleefully that "few board walks remain" in the village and predicted that all would disappear "in the course of a year." Yet, in April 1908, inspection disclosed 176 sidewalks in need of repair or replacement. By May 1910, only forty-six were found. In June 1911, the number was down to thirty-four, and by April 1914, to fifteen.

The scorn that the *Republic* had expressed about the wooden walks became high praise for the concrete ones. It remarked on their "excellence." In November 1916, it asked: "Where is the place that shows us as large a portion of … sidewalks of cement as Brockport?"

A new era had arrived in Brockport. Strolls in the village became much less hazardous. The dawn of the new century had also been the dawn of a new era for Brockport's pedestrians. Concrete walks might also become slippery and sometimes get out of line, but they created far fewer problems for their users than had their wooden predecessors.

4
Utilities

Telephones

The telephone had a long, fitful, painful gestation in Brockport. The first telephones arrived in the village in August 1881 in the form of a private line that connected the home of Dr. Rogers with his office. In fact, a number of those private two-terminal lines were installed in those early years. For instance, a resident of Monroe Avenue ran a private line to the Normal School, Fire Chief John Getty connected his residence to the Public Building, a newspaper editor ran a line from his home to his office, and so did undertaker A. D. Daily. One resident even connected his house to his barn, the newspaper editor commenting, "so he can hear the rooster crow in the early morn."

A telephone system appeared in Brockport when Captain Lina Beecher arrived from Medina in December 1881 as the Constructing Manager for the Bell Telephone Co. claiming that twenty-one businesses and professional offices had subscribed.

By May 1883, Bell had forty business and professional offices as subscribers. That, however, was its high point. The number of subscribers fell to "only a dozen" in May 1887, six in December 1887, and by January 1894, Bell was deemed to be "practically extinct."

It is easy to see why the telephone had failed. Those forty businesses and professional offices could talk to each other, but, without residential subscribers, there could be no communication between them and their customers and clients. Another problem was the rates. It cost 35 cents to call Rochester, so that three calls cost the equivalent of a day's wages for a common laborer. Another problem was the flimsy poles and wires. The poles toppled and the wires sagged from storm damage or poor quality, so that they created a public safety hazard and caused frequent, long outages.

Then, in 1898, a local physician, Frank A. Winne, entered the picture. He obtained a fifty-year franchise from the village and by March 1899 was

claiming almost 100 subscribers. In July 1903, the "practically extinct" Bell Telephone Co. came back to life, promising "thoroughly modern, up-to-date" equipment that would connect to its nationwide system. By 1903, with two phone companies operating in the village, the early problems seem to have been solved and the telephone had finally really come to Brockport twenty-two years after its first appearance.

Although Captain Beecher never returned to Brockport, he had a rather colorful career elsewhere. At various times, he was in the telephone business in Batavia and Chicago; inventing an acoustic telephone, a portable telephone, and a single railroad that "swept along at 12 mph and smoothly"; investing in a large tract of land in Tennessee that bankrupted him; president of the Genesis & Obed Railroad in Tennessee; and recruiting soldiers in Batavia for the Spanish-American War. To top it all off, in 1887, he announced that he had been the lover of Frances Folsom who had recently wedded President Grover Cleveland in the White House.

Electricity

An early problem in developing the electrical lighting industry was to generate and transmit electrical current to consumers in an entire town or city. This was first accomplished in Roselle, NJ, in 1883. Two years later, *The Brockport Republic* reported that "A gentleman called at Brockport the other day to talk about lighting the streets with electricity. The details of the early, abortive efforts are presented in the section on streets above.

In April 1888, Mr. Hillbrook of the Thomson-Houston Electric Co. told *The Brockport Republic* that 250 subscribers would support an electricity generating plant and twenty-eight lamps would "fully light the village streets at a cost of $2,000 *per annum*." The businesses in the village were canvassed and 260 potential subscribers signed up to pay 3 cents per light per night. The generating plant could be built for $15,000.

By early June, twenty-one investors had pledged $12,600 and the remaining $2,400 would come from "outside parties." The Brockport Electric Co. was organized with George D. Morgan, president; Horatio N. Beach, secretary; and George C. Gordon, son of Luther Gordon, lumber baron and president of the First National Bank, treasurer. Most of Brockport's leading businessmen were subscribers.

By September a frame 40×70-foot generating plant with a tin roof had been built by L. Gordon & Son for $1,787 on the south canal bank, about mid-way between the Main Street and Smith Street bridges. About 200 poles had been placed in 6-foot-deep holes for 12½ cents a hole.

The *Brockport Republic* of September 27 announced proudly that "In advance of most villages of similar population electric lighting has been introduced into

Brockport. This is a new manifestation of its spirit of enterprise, and brings it now new honor and fame." Arc-light street lights had been placed at thirty-three sites, mainly at intersections and "the people very generally appeared to be delighted."

By early October, sixty stores, hotels, offices, barber shops, etc., were being illuminated with 300 "burners" from 5 a.m. to 8 a.m. and 5 p.m. to 1 a.m. (no mention of the 200 other potential subscribers). However, problems remained. The carbon filaments in the streetlights survived only seven hours, requiring daily replacement. In addition to this, "a gentleman sent here ... to ... adjust ... the electric lighting apparatus, received a heavy shock," was knocked senseless, and "appeared as though he were dead." However, he recovered quickly. Moreover, homeowners were still in the dark with no word as to when they would be connected.

Finally, the *Republic* noted smugly that the contractor for an electrical system in Albion had defaulted and quoted the Holley Standard as saying that "Brockport is prouder than a boy with a new toy over its electric light, and with good reason. The new light gives our neighboring village quite a metropolitan air."

Home Delivery of Mail

The high point in the history of the postal service in Brockport in the latter half of the nineteenth century was the arrival of home delivery. Until 1971, postal service in the United States was operated by the Post Office Department, a part of the executive branch of the United States government, and was used by successive presidents as their most important patronage dispensing tool. Even after passage of the Pendleton Civil Service Act in 1881, postmasterships were exempt from its merit appointment system. The candidates for the 60,000-some postmasterships were essential elements in the national networks of presidential campaign organizations.

Therefore, Brockport's postmastership changed with virtually every change of presidents. Postmasters belonged to the incumbent president's party and had served in their campaign organizations. Exceptions were Republican John Collins, allowed to remain in office by Democrat Grover Cleveland and Democrat Henry C. Hammond, appointed by Republican Benjamin Harrison.

Between 1852 and 1900, eleven men and one woman served an average tenure of four years. The case of the Sweden Center post office illustrates the importance of partisanship. It was closed in 1859 when Democrat President James Buchanan could find no willing Democrat to be postmaster and reopened in 1861 when Republican Abraham Lincoln found a willing Republican.

Often, Brockporters fought over the office. The most notable fight occurred in 1869 when President Grant sent the name of Mary E. Baker, the widow of a Civil War soldier, to the Senate for confirmation. Horatio N. Beach, publisher of *The Brockport Republic* and a bigwig in the Monroe County Republican organization, also coveted the job and got her nomination withdrawn. A public outcry erupted, however, and Grant changed his mind again. Baker served for sixteen years, under successive Republican presidents, until replaced by Democrat Grover Cleveland in 1885, and Editor Beach nursed his wounded ego in exile as U.S. consul to Mexico, Venezuela, and Ecuador, also a patronage appointment.

The post office moved as often as the postmasters. Often, the postmasters were in business and used their stores as post offices. Until 1899, Brockporters had to collect their mail at the post office, so the arrival of the mail became a great social occasion. Men gathered to exchange gossip and swap yarns. In 1891, the Post Office Department instituted free home delivery for eligible communities. In 1893, Brockport became eligible. A postal inspector came from Washington to assess the situation. He ruled against it because the post office was too small; the village had no street signs or house numbers; the businessmen opposed it; many men objected to having their social time disrupted; and many Brockporters objected to the necessary increase in the cost of postage from 1 cent to 2 cents.

H. N. Johnston overcame the first objection in 1894 by building a fully-equipped post office on King Street and renting it to the federal government. However, the incumbent postmaster was dismissed for embezzling $3,200 and Johnston became postmaster. Finally, in 1899, the village crank, lawyer H. C. Holmes, broke the logjam. Holmes had run unsuccessfully for police judge, receiving only ten votes. He pursued legal action to overturn the result, but took time out to file a successful petition for a writ of mandamus requiring the village board to take the action necessary to enable the post office to begin free home delivery. This meant, essentially, the placement of street signs and assignment of house numbers. When that was done, home delivery began on August 1, 1899, with three carriers and twenty-five boxes.

5
Transportation

A Modern Canal

The most substantial and, probably, the most important project in the modernization of Brockport was the improvement in the connection of the village to the Erie Canal and the conversion of the Erie Canal into the NYS Barge Canal. Many aspects of the modernization of the village were accomplished without outside intervention, such as the creation of the water and sewer systems. That was not the case with the decisions for the modernization of the canal which were taken at the state level. However, Brockporters exerted influence on those decisions that affected the village. This section will focus on those local efforts.

When the canal opened in 1825, a single, wooden high bridge on Main Street existed. Before the period under review here, a similar bridge was built connecting Mechanic Street (later Park Avenue) with Fayette Street.

In May 1867, the Canal Commission called for proposals for the construction of a third village bridge to connect Perry Street with Smith Street. It would be iron, the first iron bridge in the village, and cost about $9,000. In May 1868, the state appropriated $11,000 for construction of that bridge, and that October, it called for bids to build the abutments by April 30, 1869. The low bid was $2,196 and work began in February 1869. In June 1869, the state called for bids to complete the work by November 1, and in July, a contract for the iron and wood work was let for $6,740. By April 1870, the bridge was completed but the access ramps were lacking.

In 1869, the Main and Mechanic Street bridges were rebuilt. They were made thinner to permit 1 foot more clearance above the canal surface. Also, the north end of the Mechanic Street bridge was raised 5 or 6 inches, meaning a steeper climb from Fayette Street.

Those steep climbs, especially on North Main Street caused many accidents and much difficulty. As early as 1874, the village petitioned the Canal

Commission for replacement of the Main Street high bridge by a swing bridge, a span that would pivot on a mid-canal abutment and that would be level with the adjoining streets.

The canal authorities, however, did not favor swing bridges, because they obstructed navigation. In 1876, a member from Brockport introduced a bill in the State Assembly to have a lift bridge built on Main Street. In January 1880, the village board petitioned for a swing or turn-table bridge. The following month, the State Canal Commission countered by recommending the appropriation of $12,000 for a Main Street lift bridge.

In May, Frederick P. Root, Assemblyman from Brockport, introduced a bill to authorize the Canal Commission's recommendation. The village petition had specified that the expense of operating the bridge would be borne by the state, but the bill imposed the management expenses on the village. The village board estimated those expenses at $900–$1,000 a year.

That bill did not clear the legislature in 1880, but was passed the following year and signed into law by the governor. Some unknown "loophole" in that law permitted its execution to be "avoided." The village board got up another petition, alleging that the existing Main Street bridge had become "unsafe." A. P. Butts, now Brockport's Assemblyman, introduced another lift bridge bill in January 1883. It passed the assembly and the senate (70:33) in April, but failed to get the governor's signature.

Finally, in 1887, after thirteen years of agitation by the village and procrastination by the state, a law was enacted, appropriating $12,000 for the construction of a lift bridge on Main Street. Work began on January 2, 1888, and the bridge was in operation by May. The bridge weighed 26 tons and 400 pounds. The lift mechanism was operated by hand crank from the top of the superstructure by the tender moving one 300-pound weight to raise the roadway and another to lower it. The hand operation proved unworkable, and in May 1890, it was replaced by a "water motor," defined by Wikipedia as "a positive-displacement engine, often closely resembling a steam engine."

When the bridge was opened, no gates were in place to prevent passage on Main Street when the bridge was elevated because of a disagreement between the village and the state as to who was responsible. Even with the power lift, however, the new bridge was a source of "everlasting vexation." The *Republic* complained that "unless the lift bridge system be greatly improved, it will have to be entirely abolished" and that the Brockport structure had "numerous defects." The *Orleans Republican* explained that "The thing is either suspended in mid-air half the time or else it will not work at all." In 1896 and again in 1897, the bridge required extensive repairs, but it still often malfunctioned.

The state engineer and surveyor agreed. In an 1898 report recommending their replacement by lift bridges having their lift mechanism below grade, he said the top-placed mechanisms "are liable to frequent and vexatious derangement

of their machinery involving the blocking of traffic either on the canal or on the street."

The dispute over the responsibility for the expense of operating the bridge continued. The original bill had saddled the village with the cost of paying the tenders, but the village board campaigned to have the state take that over. In 1894, a bill passed the legislature to have the state assume that responsibility, but the governor vetoed it. Finally, in 1896, after nine years of agitation by the village, the state accepted that expense.

Besides the costs of operating the bridge, the new bridge required extensive work on the Main Street and North Main Street approaches. This involved not only the surfacing, but also relocating sewer and utility lines and curbs. The decision was made to pave Main Street with cobblestones.

That controversy over Brockport's bridge occurred in the context of a desperate struggle to maintain the viability of the canal in the face of the increasingly stiff competition from the railroads. The financial fragility and creeping obsolescence of the canal surely affected the decisions of the state authorities with respect to Brockport's bridges. After all, the expenditures on the bridges would benefit Brockport, but not the canal.

The financial problems of the canal began in 1852 when the first railroads reached western New York and the packet boat lines ceased operation. The loss of packet boat traffic was a serious blow, even though excursion boats and some "express lines" continued to ply between some cities. Also, a fair number of private pleasure boats used the canal.

Much of the trouble arose from price wars, not between the railroads and the canal, but among the railroads. As they cut their freight rates, the canal boatmen were forced to do the same. Also, the price wars diverted traffic from the canal, resulting in a decline in revenues. For instance, tolls collected in Brockport declined from $55,415 in 1860 to $9,511 in 1867 and overall tonnage declined from 6.5 million tons in 1880 to 5.2 million tons in 1881.

The State Auditor's report for 1871 gives an indication of the effect the railroads were having on canal business. The tonnage of freight carried by the railroads increased from 2,167,737 in 1860 to 6,594,094 in 1869. Meanwhile, the tonnage on the canals grew only from 4,650,214 to 5,859,080. By 1881, the canal was losing enormous amounts of money: a total loss that year of $1 million. Boatmen complained that business was so poor they were losing money. In 1888, traffic declined again, by 25 percent. By 1893, there had been only two good years in the previous ten.

Some indication of the nature of the competition of the railroads is given by comparison of the shipments from Brockport by rail and canal in 1877. The canal shipped 28.1 million pounds of grains, fruit, and vegetables, compared to 5.6 million by rail. The canal shipped 547,515 board feet of lumber, the railroad 324,890. The canal shipped 1,094,862 pounds of manufactured items, the railroad 5,696,722.

The canal was best with heavy, bulky items. It shipped 26.2 million pounds of salt, stone, lime, clay, coal, iron, and steel, whereas the railroad reported none of those materials. On the other hand, the railroad shipped 931,855 pounds of livestock and the canal reported none, so the railroads took away from Brockport canal business manufactured items and livestock, and cut into its trade in lumber and produce, but made no inroads in the heavy, bulky materials.

The canal suffered many disadvantages in its competition with the railroads. Its season of operations extended only from about May 1 until about December 1, whereas the railroads ran all year. There were frequent breaks in the canal bank that halted traffic. In 1871, a break near Palmyra had boats backed up for 40 miles. Boats sank or collided and obstructed traffic. Water was often either too low or too high. Grass grew on the canal bottom and impeded the boats. Locks were a bottleneck. They often worked so slowly that long lines of boats waited their turn.

Much effort was expended in attempting to save the canal. One scheme was to lay a cable in the bottom of the canal and use it to pull boats along. A cable was laid, but never became operational because it could not function around curves. Another plan was to string an electric power line above the canal and connect to it boats with electric motors, much like electric streetcars. A 4-mile-long experimental line near Tonawanda was declared a success in 1895 and a line from Buffalo to Palmyra was said to be "all set" in 1897, but never became reality.

Steam-powered boats were also tried. They could tow four or five barges and traveled faster than animal-powered craft. In 1883, there were 4,000 boats on the canal, ninety-two powered by steam. Many more came into service later and became a common sight on the canal. Another 1881 proposal was an "air-powered" boat. In 1899, an experiment was made of canal boats being pulled by automobiles and in 1904, an "electric mule" was proposed.

A proposal was also put forth to replace the canal by a ship canal, so that ships navigating the Great Lakes could also ply the canal. Another was to have the national government take over the canal.

Finally, the most important of the many proposals was to abolish the tolls. This meant that the estimated $500,000 cost of running the canal would be borne by the taxpayers. In fact, the burden would actually be somewhat less because the financial administration of the canal (toll collectors, auditor, treasury, etc.) would no longer be needed. This proposal went on the ballot in 1882 and carried by an overwhelming majority.

During this latter half of the nineteenth century, the canal was a great economic benefactor for the village, so its decline was a serious matter locally. In the first place, the canal made the village an attractive shipping point for a large area, especially for agricultural products and lumber. This drew the shippers to the village where they shopped as well as shipped. Strangely, farm implements

do not appear on the list of products shipped, even though Brockport was a major center for their manufacture. Perhaps by the late 1860s, the railroad had displaced the canal for shipping those items.

An example of the kind of freight passing through the Brockport toll collector at the beginning of the period follows:

PROPERTY RECEIVED	
Lumber, feet	1,161,180
Shingles, thousands	189,640
Timber, 100 cubic feet	9,040
Staves, pounds	1,046,300
Furniture, pounds	11,032
Pig iron, pounds	347,200
Castings, pounds	8,699
Bloom and bar iron, lbs.	7,254
Salt, pounds	293,048
Sugar, pounds	3,745
Molasses, gallons	1,500
Nails, pounds	5,240
Crockery, pounds	1,720
Other merchandise, lbs.	96,877
Stone, pounds	1,319,557
Gypsum, pounds	634,000
Anthracite coal, lbs.	1,730,600
Bituminous coal, lbs.	1,950,826
Total valuation	$1,589,078
Total tons	30,164

PROPERTY SHIPPED	
Lumber, feet	210,484
Shngles, thousands	147,000
Staves, pounds	869,840
Wood, cords	171
Wheat, bushels	38,962
Barley, bushels	illegible
Beans, bushels	1,968
Oats, bushels	105,870
Rye, bushels	21,775
Corn, bushels	550
Butter, pounds	2,050
Flour, barrels	11
Apples, barrels	20,290
Potatoes, barrels	1,701
Tobacco, pounds	20,192
Furniture, pounds	16,789
Total valuation	$586,873
Total tons	33,595
Tolls received	$12,214.20

Additionally, during most of the period until 1883, Brockport was a toll collector's port. This provided employment for three villagers and deposits of tolls they collected in the First National Bank. The amount varied greatly from year to year. For instance, between 1859 and 1867, the lowest amount was $6,393 and the largest was $55,415. The average was $20,374, a very substantial amount at the time. However, the average for the next four years was only $7,709. Also, having the collector's port made the village a convenient stopping point for the boatmen where they could spend money in the shops and eateries.

A more realistic proposal to save the canal was actually carried out. In the late 1890s, the canal was deepened from 7 feet to 9 feet and the locks lengthened to accommodate larger boats that, presumably, would make the canal business

more profitable. In late 1895, the legislature approved a budget of $9 million. The eventual cost was $16,000,000. By lengthening the locks, the time for a boat to travel from Buffalo to Albany was said to be cut in half.

By November 1897, deepening had begun on the Brockport stretch. The work was finished by late 1899. At the same time, the Main and Fayette Street bridges were re-planked. Despite all of the efforts, traffic continued to decline. It fell 50 percent in the five years 1894–1899 and dropped another 10 percent by 1901. The 5,000 boats in 1884 had become only 800 by 1899, so by 1900, the state needed to make a decision. It could leave the deepened canal as it was with its ever-declining traffic, abandon the canal as a lost cause, or rebuild it for power craft. Under the leadership of Governor Theodore Roosevelt, the decision was made to rebuild it. The cost was estimated at $60 million, though an alternative estimate of $79 million was also put forth.

The proposal was to expand the canal from a width of 52 feet at the bottom, 70 feet at the top, and 9 feet deep to 75 feet at the bottom, 120 feet at the top and 12 feet deep. The new canal would accommodate boats with 1,000-ton capacity, compared to 240 tons on the existing waterway. The new canal would use a canalized Mohawk River, Oneida Lake, and other rivers. The only substantial length of dug canal would be the 64 miles from Palmyra to Lockport.

In January 1903, a bill to appropriate $81 million for reconstruction of the canal was introduced in the Assembly. By July, the estimated cost had grown to $101,000,000 and was to be proposed to a popular referendum in November. Much opposition was expressed to such a large investment. One newspaper called it "the most colossal extravagance ever proposed for any member of the Union." The *Republic* repeatedly characterized it as a "monstrosity" and *Engineering News* called it "nothing less than an economic crime."

Despite the criticism and the enormous amount of money involved, the proposition carried overwhelmingly. Generally speaking, the communities on or near the canals cast lopsided majorities for the issue, while those further away were negative, but had lower turnout and closer votes. The name of the rebuilt canal was to be the New York State Barge Canal, as barges moved by diesel or steam tugboats were expected to form its main traffic.

Passage of the bond issue did not, however, lead to an early beginning of construction. As late as July 1907, the state had not sold the bonds, so construction had not yet begun. Finally, in November 1908, construction crews and equipment arrived in the village and the work began. A company from Cleveland had the $1,047,994 contract for the 7 miles in the Town of Sweden. Also, property was being taken to allow for the expansion. A month later, the Brockport firm of M. A. Cleveland & Son bought the contract. Cleveland announced that it would begin construction in the spring and complete it in three years.

The Perry Street bridge was to be reconstructed to accommodate the larger canal and access roads were to approach from Smith, Perry, and Clinton Streets

with a concrete staircase for pedestrians. The type of bridges for Main Street and Park Avenue was undecided. Two members of the village board met with the Canal Advisory Board in Albany and petitioned to have three lift bridges. They were told that Main Street and Park Avenue would have lift bridges at a cost of $40,000–$50,000 each (in fact, they cost $90,000 each). Perry Street would remain a high bridge. It would be rebuilt with the grades of the approaches "much improved over present conditions."

The $101,000,000 bond issue of 1903, however much it seemed a "monstrosity" at the time, proved to be inadequate and the state floated another $27 million issue in 1915 to enable it to complete the reconstruction. The main reason for the additional amount was the unexpectedly high cost of damage claims by land owners.

The new bridges were 131 feet long, compared to 80 feet for the old Main Street bridge. They had 25-foot-wide roadways and two 3-foot-wide sidewalks. Machinery to operate the new bridges, unlike the old Main Street lift bridge, was located in two pits 18×45 feet wide and 35 feet deep and weighing 31 tons. A total of 10,000 cubic feet of earth had to be removed in excavating the pits and 3,000 cubic yards of concrete were used. The cement for the concrete was brought to Brockport in twenty-five railroad carloads. Each of the bridges themselves weighed 200 tons. Counterweights were equally heavy, so that the bridges required only 12-horsepower motors to raise and lower them. The machinery could be cranked by hand, if necessary.

The excavation for the canal in the Brockport area had been completed in mid-1913, so when the bridges were installed in April 1915 and formally opened on July 7, the barge canal in the Brockport area was complete. Brockport finally had its modern canal. It remains today basically what it was a century ago.

Bicycles

In the late nineteenth century, a bicycle craze swept the country. The bicycle was viewed by many as a new form of transportation and recreation that improved upon the existing modes. For some reason, Brockport was very slow joining that fad.

The first practical bicycle had been invented in France in the early 1860s. It had a large front wheel and a small rear one and was called the "Ordinary." The modern chain-driven bicycle with two wheels of equal diameter did not appear until about 1885.

The first mention in *The Brockport Republic* of a bicyclist visiting the village was on September 2, 1880. It had a front wheel diameter of 56 inches. The following month, "Bicycles of home manufacture have begun to make their

appearance on the streets." By April 1881,"Some boys ... trying to 'break-in' a bicycle on Spring Street have afforded considerable amusement for the people residing in that section."

For the next few years, the *Republic* reported on local residents buying bicycles, their frequent accidents, races, and demonstrations of fancy riding. The Ordinary bicycle was especially prone to accidents. Some had no brakes and riders were often thrown forward over the front wheel in what was called a "header." Wilson H. Moore, who later owned Brockport's first automobile, also bought one of the first Ordinaries. His pioneering spirit served him poorly, as he suffered two serious accidents.

Additionally, the *Republic* reported quite a number of cases of horses bolting when frightened by the new-fangled machines and pedestrians being knocked down on sidewalks by bicyclists. Indeed, the sidewalks seemed to have been favored by the bicyclists because they were in better condition than the streets.

The problem of bicycles on sidewalks came before the village board in July 1882, but it took nineteen years before they finally resolved the issue. Not until September 1886 did it enact an ordinance, providing that "no person shall ride upon a bicycle upon any sidewalk in the village of Brockport." Violators would incur a $10 fine.

The board next confronted the issue in June 1892 when an effort was made to organize a bicycle club in Brockport and its leaders asked the village board to enact a set of rules for the use of bicycles in the village. The village fathers refused to do so in the fear that they would incur a liability in doing so. As a result, the club disbanded.

Apparently, the board found the 1886 ordinance unworkable and replaced it in May 1895 with a less restrictive law that identified certain streets and certain periods of the day when bicycles were forbidden on sidewalks. It also added the following provision: "No person shall engage in fast or fancy riding upon any sidewalk in said village at any time."

That ordinance did not please many pedestrians. In May 1896, one of the village board members reported that seventy-five residents had complained to him about the risks they ran in using the village's sidewalks and also that the ban on fast or fancy riding was impossible to enforce. The board repealed the 1895 ordinance by a 3:2 vote and restored the 1886 law by a 4:1 majority. In 1901, it revised the ordinance yet again by incorporating in an ordinance on trash removal one sentence: "No person shall ride any bicycle upon any sidewalk in said village." That remains the law today.

One important part of the national bicycle craze was the organization of bicycle clubs, whose members took bicycle excursions, sponsored races, and held social events. The *Republic* reported clubs being organized in many surrounding towns as early as 1880, but not until the abortive effort of June 1892 was an attempt made in Brockport.

The only bicycle club formed in Brockport by the end of the century was the "Brockport Ladies Bicycle Club." It was organized in July 1895 with "about a dozen charter members" and "the colors of the sweet pea are to be worn." It seems to have been active for a couple of years, but soon faded away. Two months earlier, the men had failed in another attempt to form a club. No men's club was ever formed, but a group of men occasionally organized races on village streets and nearby roads, complete with timekeepers and prizes.

In 1891, the *Republic* reported that there were 8,000 bicyclists in Buffalo, and a year later, it said that Rochester had 3,126. Meanwhile, bikes were "becoming numerous" in Brockport in April 1892 and numbered "about 100" in January 1895. By then, apparently, the *Republic* thought the interest in bicycling of enough interest to make "Of Interest to Bicyclists" a regular feature in its columns, giving useful information of both local and distant origin.

Another measure of the difficulty of Brockport joining the bicycle craze was the repeated failure of shops to stay in the business of selling bikes. Between 1888 and 1898, at least seven merchants offered bicycles for sale, a music store, a jewelry store, a tailor shop, a general store, a hardware store, and a "department store." In April 1893, H. W. Merritt seems to have opened the first true bicycle shop in the village. None of the shops lasted in the business very long. Most Brockporters seem to have bought their bicycles in Rochester.

In one respect, however, Brockport participated fully in the bicycle craze—its avid enjoyment of bicycle races and fancy riding demonstrations. Traveling shows and carnivals visited the village regularly with such events on their programs and local entrepreneurs organized similar activities. One of the most popular was the inclusion of bicycle races in the Brockport agricultural fairs beginning in 1896, when five races were added to its schedule.

Apart from the races and riding exhibitions, the bicycle craze in Brockport was a faint echo of its national counterpart.

Automobiles

Brockport shared in the ambivalence with which much of the nation greeted the arrival of the horseless carriage. This section will trace the evolution of the attitudes of Brockporters toward the automobile and of its importance in their lives as reflected in the pages of *The Brockport Republic*.

The *Brockport Republic* first mentioned a horseless carriage in 1897, reporting that such a vehicle had visited Fairport and "went off at a great rate." Soon thereafter, the *Republic* weighed in with this prediction about its future:

> The opinion at the present time of those best fitted to judge of the future of
> the motor carriage, is as follows: Steam will probably be used and it will be

generated by means of liquid fuel. It will be necessary to invent suitable air-condensers to obviate the clouds of steam and to provide means to dispose of the smoke and cinders.

Many of the jokes that the *Republic* printed as "fillers" at the bottom of columns poked fun at automobiles. For instance, one called "the automobile face" that of a man in an automobile who "looks as if he wanted to get home alive, but knew he wouldn't."

Some of its filler jokes included:

I guess Mrs. Swagleigh must know that she looks well in black.
 Why?
 She gave her husband one of those powerful racing automobiles for a birthday present.

A man who can fix an automobile and stay good natured is too good to be left running around loose during leap year.

Three days after a man becomes the owner of an automobile he learns what a useful tool a monkey wrench is.

What is the difference between the quick and the dead?
 The quick are those who are quick at getting out of the way of motor cars and the dead are those who are not.

The *Republic* used a "horrifying" automobile accident in France to predict that "Stock in automobiles will be at a discount for a time at least from now on, fear will reign supreme." The *Republic* nicknamed automobiles "buzz buggies" and called them noisy, smelly, and dangerous and complained that they frightened horses. They were unreliable and expensive, and they were driven too fast and the drivers are rude and reckless.

As late as 1904, the *Republic* continued to have doubts about the automobile. It said: "The horseless age, which some persons predict, is evidently still remote." It cited as evidence the estimate by the secretary of agriculture that "the value of horses at the beginning of the current year [w]as more than a billion dollars."

In 1904, the *Republic* quoted approvingly: "One of our businessmen who has had a 'hankering' for an automobile," but said "after riding in an auto several times and noting its 'fixings' that have to be done, that he would give more for a good horse than any horseless carriage in existence, and he is not much of a 'hoss' man either." However, by May 1905, the *Republic* was admitting that "inasmuch as the automobile is no longer an experiment but has 'come to stay' owners of horses will have to make the best of the matter."

The first automobile to visit Brockport seems to be one that arrived in 1899 on a trip from Rochester to Brockport via Churchville and Bergen that required one hour and thirty minutes. The event was sufficiently noteworthy to deserve having "a picture of it and the boys displayed in a case at the entrance to Mr. Conklin's photography rooms." The next mention of "an automobile in town" occurred in October 1901, when it entered Brown's livery stable, frightening one of the horses.

The first automobile owned by a Brockporter was the Steam-Locomobile of Wilson Moore. He had bought it "conditionally" in May 1900. In July 15, 1902, he was photographed taking William H. Seymour for a spin in it on Seymour's 100th birthday.

Though there was only one automobile in town, by September 1901, Lester's Dry Goods was already advertising its stock of "automobile cloaks," and toy automobiles were being advertised in time for Christmas 1902, priced at 25 cents to $1.

Brockport's second automobile belonged to Philip F. Swart, cashier at the First National Bank. When he bought it in July 1902, the *Republic* remarked sardonically that it was "warranted not to shy at infant cows beside the road, traction engines, baby carriages, etc. and it will 'stand without hitching.' That it will not run away with friend Swart is not in the contract we believe." That prediction came true in September 1904 when the steering gear of Swart's automobile became "disarranged" near Middleport, veering into a ditch and throwing Swart out. He and his wife and child left the car in Middleport for repairs and took the trolley home.

Mr. Moore's automobile seems to have been the cause of the first auto-related accident in the village. In June 1902, his vehicle met a horse-drawn carriage on Main Street and, though he "stopped quickly upon the first evidence of the horse appearing frightened," the horse bolted. In its wild run, both occupants of the carriage were thrown out and injured, though not fatally.

That accident was an example of a serious problem resulting from the introduction of automobiles to Brockport: the difficult relationship between the occasional auto and the much more numerous horse-drawn vehicles. As they were so unfamiliar with the noisy contraptions, horses were easily frightened by them, running away beyond the control of their drivers.

An example of this occurred on North Main Street in August 1904 when a "four-seater" automobile from Buffalo overtook a horse-drawn wagon with three passengers. The horse shied, overturning the wagon and throwing its passengers to the ground. One of them suffered a deep scalp wound and dislocated shoulder.

Not all the victims of the first series of automobile accidents were so fortunate. One of those involved Luther Gordon, one of the grandsons of the lumber king. In January 1906, the *Republic* reported that he had bought "one of the finest automobiles made." It caused Brockport's first automobile collision:

While returning from the Methodist Sunday School picnic at Troutburg ... a carriage [was] run into by an auto driven by Luther Gordon between this village and Clarkson. Both were on their way to Brockport, and ... met several teams ... and he did not see the carriage. Fortunately the auto was running very slowly and ... [a]ll escaped without bruises, except Miss Brockway, who was thrown from the wagon and dragged a short distance.

The very next issue of the *Republic* reported that the hapless Luther Gordon was involved in a second accident in a week, again involving a horse-drawn carriage. The same issue reported two other accidents in which autos frightened horses. Gordon and his auto had still another mishap in August 1906 involving still another horse-drawn carriage.

Another of the early autos in Brockport was a touring car acquired in 1905 by Gladys Morgan, youngest daughter of Dayton S. Morgan, the reaper king. Her brother, William, already had bought one in August 1903. Grace's vehicle caused the first fatal automobile accident in the village. In 1906, Gladys parked her "large automobile" alongside a horse-drawn vehicle in front of a Main Street store. The horse bolted, ran north on Main Street, upset the carriage of one Addison Palmer, "precipitating [him] with such force to the ground that the right side and back of his head was badly crushed in." So, between August 9 and September 1, 1906, four Brockport autos were involved in five accidents, one fatal.

The *Republic* reported that the other two grandsons of the lumber king, George and Fred, had bought Covert make automobiles in March 1904, but already in April 1905, Fred had bought another new automobile, as had Wilson Moore, "much finer than any these gentlemen have owned heretofore"—Moore after three years and Gordon after one year of owning their previous vehicles. Moore seems to have bought still another automobile the following year, for the *Republic* reported in May 1906 that he had "a new Thomas 'flyer'."

In August 1905, the *Republic* noted that "We see on our streets many motor cars," and by August 1906, it estimated that the village had twenty automobiles and boasted that "no place in the state probably has as much invested in them as has Brockport." The following month, the *Republic* predicted that "there will be a good many more automobiles in Brockport next year than there are this" (yet in April 1907, it admitted that it had not heard "of any new machines having been bought"). By June, it could announce that "New automobiles are continually being bought by our citizens." Even were that prediction to come true in a town of some 3,500 residents, the Automobile Age would hardly be arriving.

In addition, the *Republic* complained that "there was hardly a medium-priced one in town" and hoped that less costly ones might become available. Moreover,

the *Republic* reported in December 1906 that "the automobiles owned in Brockport have gone into winter quarters," so Brockport's autos were still pretty much a fair weather plaything of the rich. Perhaps the first sign that this was changing was the appearance in February 1909 of the first advertisement for a Ford automobile, price $850, as it was the Ford Model T, introduced on October 1, 1908, that really ushered in the Automobile Age in America and, presumably, in Brockport.

In April 1909, the *Republic* reported: "From all reports there will be more automobiles than carriages seen on our streets this summer." By June, it noted: "Over eighty automobiles are now owned in the village of Brockport and Town of Sweden, and more are being added to the list every week." In May 1910, it commented: "Automobiles are thicker than horses many days on our streets." The *Republic* had become sufficiently accepting of the automobile by July 1909 that it advocated formation of a Brockport automobile club to organize "two or three day" group tours.

By April 1908, automobiles had become sufficiently numerous and dangerous in Brockport that the village board enacted two ordinances regulating automobiles. One set a speed limit of 10 mph and violators were subject to a $10 fine. The speed limit was raised to 18 mph in May 1916. Another 1908 rule required automobiles being operated in the village to have a means of "alarm" to warn pedestrians and other automobile drivers and, if operated between dusk and dawn, to have lights before and aft. In the same issue, the *Republic* published the first advertisement for an auto repair shop in the village. About the same time, used cars were first offered for sale.

The first mention of an automobile dealership appeared in April 1905. A. B. Elwell was said to sell "eight kinds." In the first advertisement by an auto dealer in the *Republic*, in 1906, the United States Automobile Co. of Rochester had for sale Winton, Regas, Franklin, Northern, Pierce, Marion, Orient, and Oldsmobile makes.

Brockport's 1907 business directory has only one mention of automobiles. A livery stable advertised "Automobiles and Wagons washed." However, in that year, the Brockport Wagon Co. manufactured two automobiles and then went out of business. Al McBride has one of them in his private museum on Brockport's East Canal Road.

The *Republic* was quite impressed by the dual use being made of some Brockport automobiles in 1909:

Brockport has automobiles for gathering and delivering laundry, baked goods, carrying water and gas supplies, another for telephone supplies, during the week. Then on Sunday in the evening, with different bodies, these four horseless carriages give pleasure to their owners and friends. Long live the buzz buggy.

Another indication of the increased popularity of the automobile was the decision in November 1913 by the village board to buy an automobile for the use of the Street and Water Departments. This met with considerable criticism from the taxpayers, who regarded it as a waste of their money when rentals or horse-drawn vehicles might suffice.

Fifteen months later, the fire department followed suit. In response to a petition signed by twenty-five residents, the village board held a referendum on March 16 on the request by the Harrison Hose Company to appropriate $1,000 for the purchase of an "automobile fire truck." The proposition carried—74:65 with thirty-five blank ballots. The Harrisons announced on August 23 that they had bought the truck.

The increasing popularity of the automobile at the expense of horse-drawn vehicles had one very negative effect on the village. The Rochester Wheel Company that had taken over Building 2 of Dayton S. Morgan & Co. specialized in wheels for buggies and wagons. It went bankrupt in 1913 "mostly as a result of the coming power and popularity of the automobile," according to the *Republic*.

Apparently, Editor Blossom of the *Republic* finally had become fully reconciled to the Automobile Age by June 1915, when he announced that he had "taken the agency for the ["famous Hudson"] car, convinced after driving one of the original Hudsons for five years that the car is not to be excelled at anywhere near the price." That price was "only $1,350 F.O.B. Detroit." The following week, the *Republic* featured a large, illustrated advertisement for the Hudson Six, announcing that P. A. Blossom was the agent for Sweden, Clarkson, Hamlin, Parma, and Ogden. After that, the fillers poking fun at automobiles were replaced by others boosting the "famous Hudson Six."

In March 1916, the *Republic* reported that there was one automobile registered for every twenty-five residents of Monroe County. If Brockport was about average in auto density, there were about 140 automobiles in the village. Of course, their density continued to increase over the decades, but if one in every twelve to fifteen families owned an auto, Brockport was approaching the Automobile Age.

Trolley

An important part of Brockport's transportation system for more than twenty years was the electric railway. As usual with other aspects of Brockport's modernization, it aroused heated controversy.

Its history began with the incorporation in 1902 of the Brockport, Niagara & Rochester Railway Company. Its mission was to construct a 44-mile-long electric railway from Rochester to Medina. It was capitalized at $500,000. Its directors

were Frederick Beck of Brockport, president; W. S. Shields of Waterville; and S. J. Spencer of Buffalo.[1]

On November 3, 1902, Beck appeared before the Brockport village board to petition for a franchise to "construct, maintain, and operate" a "street surface railroad" that would wind through the village beginning at the village boundary on State Street and ending at the western end of Erie Street. The cars would be "moved by means or power of electricity." The request was tabled to the following week. At the following meeting, the company asked for a further delay to the next meeting, and at the November 19 meeting, it requested a further two-week adjournment.

Meanwhile, at the November 17 meeting, Charles B. Hill of the Albion Electric Railway presented a lengthy "form of consent" and asked the board to approve it. It proposed to construct an electric street railway to run from the western end of Erie Street to the eastern end of State Street. The "form of consent" was voluminous, providing for all sorts of conditions and protections.

Mr. Hill presented petitions signed by "about 600" Brockporters favoring the project. A "remonstrance signed by all of the property owners on State Street between Main and Park Avenue and nearly all between Park Avenue and Gordon Street" opposing it was presented. Four residents of State Street spoke against it.

Mr. Hill responded, describing his company's plans and reporting that agreements had been reached with Albion and Medina and were being negotiated with other villages along the proposed route. He said that they had "not had any difficulty until we came to Brockport." He claimed that only four "or not to exceed eight" opponents were really opposed and that the others had simply signed at the request of their neighbors. He said that no other route through the village was feasible.

Mr. Hill said that they could not run on State Street unless they had the consent not only of the village board, but also of a majority of the property owners. Otherwise, they would go to the Supreme Court and have commissioners appointed. If the commissioners ruled against them, that would be it. If they supported the company, their opponents would "have the right to appeal."

A long discussion ensued, involving trustees and members of the public. At one point, Wilson H. Moore, a State Street resident, warned, "The residents of State St. will fight the matter to the end.... The whole street is up in arms against it."

Board members proposed some minor changes in the agreement, which Mr. Hill accepted. However, he refused to agree to pay the village a percentage of the company's revenues. The board then went into executive session and adjourned without acting on the agreement.

The board held a special meeting on November 20 for the sole purpose of considering the proposed agreement. A Rochester attorney presented a petition

signed by "about 400" Brockporters calling for a fifteen-day delay before acting on the proposal to give the people time to study the agreement and consider possible changes. He said that they favored the railway, but wanted to learn about the details.

A motion was made to approve the agreement. An amendment to the motion was made and seconded to postpone action for two weeks. The amendment was defeated (4:3) and the main motion carried by the same vote. One member who was absent had said that he would support the agreement.

In January 1903, it was announced that the street cars would run at 25 mph outside the village and 15 mph within. In March, work was scheduled to begin in a few days, but in May, the Albion paper reported that the financing necessary to build the railway "was not yet in sight" and that work that had begun in Albion was halted. Only 1.7 miles of track, all in Albion toward the Mt. Albion cemetery, had been built.[2]

In 1905, the Albion Electric Railway merged with two other railway companies that had been chartered in 1904 to form the Buffalo, Lockport and Rochester Railway. Charles Hill was the president, but was quickly replaced by J. M. Campbell of Kingston, Ont., and the company was taken over by a Canadian syndicate.

After the long hiatus, apparently due to financial problems, the new owners announced that they planned to complete construction from Rochester to Brockport by the spring of 1907 and on to Albion by the end of the summer. Track-laying began in September 1906 and four boatloads of ties were unloaded in Brockport.

The original agreement with the Albion company had included the provision that the consent to build and operate the railway was given to the Albion company and its "successors, lessees, or assigns." Nevertheless, Mr. Hill appeared at the April 30, 1906, meeting of the village board to ask that the agreement be replaced by one identifying the Buffalo, Lockport and Rochester Railway as the franchise owner in order "to remove any question that may arise as to the right of the company to construct its road under assignment of said consent from the Albion Electric Railway Company in the minds of the attorneys for any prospective purchasers of the bonds." Once again, he emphasized that Brockport was the only municipality along the route where opposition was expressed.

The village board took advantage of this opportunity to amend the consent to include provisions more favorable to the village. Especially, it required that the company macadamize and install curbing along Erie and State Streets and lay bricks between the tracks on State Street and at the intersection of State, Main, and Erie Streets. Also, it imposed on the cars a speed limit of eight miles per hour. The final document was many pages long with every possible detail covered. The board postponed its decision twice, but finally, on July 9, adopted the consent. The vote was not reported in the minutes.

On June 26, 1906, an injunction issued by Special County Judge J. B. M. Stephens ordered that "further action under the franchise granted" to the railway be halted was served on the board. It had been initiated by Wilson H. Moore on the grounds that Board "President J. W. Larkin was not eligible or qualified to hold that position, alleging that he was not the owner of real estate and that his name does not appear on the tax roll for 1905." At its July 9, 1906 meeting, the board read into the minutes an order by Judge Stephens vacating that injunction, after a hearing at which the defendants and an attorney for the plaintiff were present.

That was not the end of Moore's campaign. When he and his neighbors had been overruled by the village board in November 1902, they had appealed to the Appellate Division, which had appointed commissioners to consider the matter. Then Moore filed a petition, questioning the legality of the incorporation of the company. He also alleged that the real purpose of the company was not to build the trolley line, but to string an electrical transmission line so the company could sell in the United States electricity it generated in Canada for which no market existed. His petition was denied and he filed an appeal with the Court of Appeals. Before that appeal was decided, Moore filed another petition, asking that a decision on that appeal be deferred until the Court of Appeals acted on the appeal of the property owners.

The need to renew the consent also gave Moore the opportunity to enter the fray again. He hired John Pallace, Jr., a local attorney, to represent the opponents. At the April 30, 1906, meeting, he presented a petition signed by twenty-two State Street residents opposing the consent, but when a Trustee asked him to state his objections, he deferred to Pallace, who simply asked for a postponement of two weeks so that he could study the document.

Editor Beach also weighed in on the pages of the *Republic*, with a set of demands. They included paving both streets with brick or macadam and charging the company a franchise fee of anywhere from $15,000 to $25,000. The money could pay for the new school building that the village needed and it could be named the "Hill" school in honor of the company's "affable attorney."

On April 30, 1907, the commission finally handed its decision to the Appellate Division. It was favorable to the trolley company. Moore opposed the report and the Appellate Division required the parties to submit written briefs supporting their positions by May 10. The Appellate Division confirmed the decision of the commission on the afternoon of May 28, and "an hundred or more" workmen, including "Dagoes" carrying "lanterns, shovels, and pickaxes, etc." began work on State Street at about 9 p.m. The company was anticipating that Moore would carry his case to the Court of Appeals for another injunction.

Already by May 30, "an almost incredible amount of work has been done by hand and machinery." By June 6, "an extraordinary amount of work has been done." However, repeated efforts to predict the opening date for the line were frustrated by litigation and construction delays.

The first trial run through Brockport came on May 7, 1907, but regular service did not begin until September 1908. The first regularly-scheduled trolley ran from Rochester to Brockport on the night of September 2, 1908. It began its return trip at 6:10 a.m., picked up several passengers in Brockport, and arrived at Glide Street in Rochester with a "well-filled car."

Moore never asked the Court of Appeals for a new injunction, as the company feared. He seems to have given up after the Appellate Division confirmed the commission's findings. On July 29, 1907, less than two months after the final decision of the Appellate Division, he traveled deep into the north woods of Canada, accompanied by his physician and two Indian guides. On the 31st, he arose after breakfast and walked from their camp a short distance into the woods, where he shot himself in the head with a revolver, dying instantly, at age forty-seven.

In its very laudatory obituary, the *Republic* called him a "good citizen and a steadfast and loyal friend" and "an active and aggressive factor in the activities of Brockport." It also reported that "his nervous condition was known to be of a serious nature" and that "he did what he deemed to be his duty in the most positive and forceful way possible."

The *Republic* expressed the belief that "It is quite evident from facts at hand that it was not a premeditated act, but was the result of accident or sudden and temporary insanity." However, it offers no explanation for why he was wandering in the Canadian north woods with a loaded revolver, not exactly a hunting weapon, and how he came to shoot himself in the head "accidentally." Nor is there any mention of target practice. Given his temperament, his obsessive battle with the trolley company, his final defeat after the long and expensive struggle—both monetarily and psychologically—and his serious "nervous condition," suicide seems a more likely explanation, perhaps the result of "sudden temporary insanity."

The trolley provided Brockporters with convenient and inexpensive transportation to Rochester, Buffalo, and points in between. It was a useful alternative to the New York Central Railroad that had operated in the village since 1852. Brockporters welcomed it as a way to break the New York Central's monopoly and perhaps restrain its fare hikes. The Buffalo, Lockport and Rochester Railway was reorganized in 1919 as the Rochester, Lockport and Buffalo Railroad. It ceased operation on April 30, 1931, the victim of the rage for automobiles.

6
Institutions

State Normal School

One of the most important steps in the modernization of Brockport was the creation of an institution of higher education through the establishment of the State Normal School in 1867–68. Like so much else in the modernization process, this caused a great deal of difficulty and conflict. In presenting this account, I have relied heavily on Wayne Dedman's excellent history of the college, *Cherishing This Heritage* (Appleton-Century-Crofts, NYC, 1969).

The Brockport Collegiate Institute that had been founded in 1841 was suffering fatal financial problems by the mid-1860s. In fact, the school had been sold at sheriff's sale to satisfy its debts, which had reached the amount, enormous for the time, of $12,976.20. Fall term 1866 was cancelled.

By a coincidence that was very fortunate for Brockport, as that was happening, New York State was deciding to enter the teacher training business through the establishment of several "normal schools." Learning of this in early 1866, the Institute's Board petitioned the state legislature to locate one of the normal schools in Brockport.

This set off an epic struggle involving outright falsehoods, exaggerations, manipulated elections, electoral and referendal defeats, rejected pleas for support from the Town of Sweden, the Monroe County Board of Supervisors, and the state legislature, lawsuits, failed bond issues, refusals to pay taxes, aborted public subscriptions, unrealistic cost estimates, a deeply-divided community, bitter attacks in public meetings, and on and on. One can only stand in awe at the dogged persistence and wiliness of its advocates. They met with repeated setbacks, but always fought back until finally they won. Without that effort, the major educational institution that exists today would never have come about.

In that January 23, 1866, petition to the state, the board offered to convey title for the institute's property to the state. Never mind that it no longer owned the structure. Also, it would construct, at no expense to the state, "such additional

erections" as the state might require. It asked only that it be allowed to conduct a school for Brockport children in a portion of the building. It stretched the truth beyond the breaking point in describing the school as "a large and flourishing Institution" and in estimating the value of the structure at $40,000 to $50,000. Never mind that it had been sold at sheriff's sale in 1863 for $386.

The state passed a Normal School Act on April 16, 1966, authorizing the establishment of four institutions. It invited proposals for their location from "the board of supervisors of any county in this state, from the corporate authority of any city or village, from the board of trustees of any college or academy, and from one or more individuals."

The BCI Board solved the problem of its lacking ownership of the school on April 20, 1866, by offering to transfer the property to the village of Brockport, which would pay off its indebtedness and offer it to the state. The village board responded by calling a public meeting to discuss the offer and the consequent taxation that would be required.

The Normal School issue split the community into two highly-emotional camps. Its advocates argued that the institution would be an asset to the entire village, while its opponents contended that the tax burden would fall most heavily on those who would derive no benefit. Only property taxpayers were allowed to vote in the referendum that followed. They defeated the proposal (139:102). However, thirty-five taxpayers who had petitioned for the referendum had not voted. So, the village board added their number to the affirmative votes, though this still meant a loss by 139:137. Next, the village board discovered that the taxpayers voting for the proposal had assessments of $185,800, while the opponents had only $106,460.

This dubious calculation enabled the trustees to conclude that the proposal had been approved and they submitted a petition to the state. However, they agreed to limit to $37,000 the amount of taxes to be raised with the understanding that another $4,000 for equipment would be found elsewhere. This was at a time when the operating budget of the village was only about $1,600.

Not surprisingly, the opposition protested those underhanded tactics and submitted a petition to the state objecting to the location of the school in Brockport. This led the village board to call another public meeting for July 30, 1866, at which a second referendum was agreed to. Both men and women taxpayers were permitted to vote this time, the women by proxy, and they favored the proposal (165:131).

The state commissioners received fourteen proposals and announced on December 3, 1866, that Brockport, Binghamton, Potsdam, and Fredonia had been selected. Once that decision had been made, the village board undertook to solve the financial problem. In March 1867, it issued bonds in the amount of $20,576.04 to cover the BCI indebtedness.

With its financial house seemingly in order, the board undertook the construction of the two wings to the building that had been promised to the

state. The lowest bid was $41,500, well over the limit of $23,000 that it had set. By trimming some costs, the board reduced the final figure to $24,000 and construction began.

The former opponents of the Normal School now accepted that it was a *fait accompli* and campaigned for the charter election of April 2, 1867, by insisting on "the economical management of village affairs." They also implied that the incumbents had favored some business interests unfairly. The *Republic* reported that "Probably no election ever occurred since the village was founded at which there was such intense interest" and "no election ever ... left so much bitter feeling." The four incumbents who were staunch supporters were re-elected by substantial majorities, while their lukewarm colleague was replaced by a businessman who was a bit of a loose cannon in politics.

With their mandate renewed, the board enacted a tax of 1½ percent on the assessed value of real and personal property in the village. This aroused another wave of anguished opposition, so the board decided to defer collection of the tax until the spring construction season and issue another $7,000 worth of bonds to finance ongoing construction costs. Board minutes for December 9, 1867, include a list of bondholders. Luther Gordon bought $3,500 worth. Twenty-three other people, apparently mostly local residents, especially businessmen, purchased the remainder in amounts ranging from $100 to $300. At every board meeting that year, payments for work on the building were authorized.

Opposition to the tax appeared in the village. Some taxpayers refused to pay and the village seized property in default of payment. Most notably, a "pile of good pine lumber" was seized from Luther Gordon, a leading businessman and politician who had headed the opposition slate in the April election and had refused to pay the tax. He sued the members of the board, alleging that the seizure had caused him severe loss. The court found that the board's action had been legal and, presumably, Gordon paid the tax.

The Normal School controversy also entangled the November Assembly and judgeship elections with leaders crossing party lines to back candidates based on their positions on the Normal School. Nevertheless, party loyalties prevailed and the Republican candidates won, as usual, regardless of their Normal School stands.

During this time, the board also sought relief from some of its financial burden by petitioning the County Board of Supervisors for a $30,000 grant. Other counties had done so in support of other Normal Schools. Two Brockporters who opposed the Normal School spoke to the Supervisors, who rejected the appeal nearly unanimously.

Residents of Sweden outside the village also became involved in the battle. A bill had slipped through the legislature authorizing the levy of a Normal School tax on town taxpayers. As village residents constituted a majority of the town population, Swedenites suspected that Brockporters intended to extend the tax outside the village.

At a special meeting on February 12, 1868, the Brockport Board called a meeting of "the electors of the Town of Sweden ... for the purpose of discussing the question of asking an appropriation from the town at the next annual meeting to aid in the erection of the State Normal School Building." That meeting, on February 19, opened with a plea by President Anderson of the University of Rochester on behalf of the proposal.

There followed a debate between two opponents and one advocate until an effort to adjourn resulted in great disorder, including an attack on one of the trustees by the dog of an advocate, amid cries of "sick 'em, sick 'em, git out, git out." The meeting deteriorated further with "from five to ten trying to speak at once, and many more yelling" and finally, after some further discussion, adjourned until the following Saturday at the same place.

At the adjourned meeting, the debate became very heated, but, unlike its predecessor, did not break down in disorder. Much of the argument concerned the anticipated cost of the structure. The opponents alleged that it would cost $54,000, while the proponents insisted on only $43,000. Some of the comments attacked their antagonists personally and others alleged that the "Normal School ring" was showing favoritism by spending Normal School funds only with merchants who supported the plan.

An attempt to settle the issue was made by opponents of the proposal at a special town meeting on February 29. Apparently, the proponents boycotted it, as the vote was reported to be 396:0 against levying the tax on the town. The Normal School advocates had not yet given up, however, and, at the regular town meeting on March 3, proposed a resolution that the Town of Sweden appropriate $20,000 for the Normal School building to be raised by taxation. It carried 235:2, the opponents being the boycotters this time. However, the law authorizing the appropriation required that it be supported by a majority of all votes cast in the election. As 749 votes were cast in the Supervisor contest, the appropriation failed. Moreover, the anti-Normal School faction elected lead opponent Luther Gordon as Supervisor.

The next round in the battle was the village elections of April 7, 1868. Four of the incumbents stood for re-election, one retiring and being replaced by another supporter of the Normal School. Editor Beach put together a "conciliatory" ticket, composed of three supporters of the school (including himself) and two who had opposed it. He alleged that if the old board were returned, it would impose a four percent property tax, whereas the conciliatory board would continue the tax at 1 percent and issue bonds. The anti-Normals had planned to run a slate, but Beach persuaded them to stand down in favor of his.

In the end, the Beach ticket fielded only four candidates, three pro-Normals and one anti. The old board won in a huge landslide, by an average of 74 percent of the turnout. In a post-election editorial, Beach claimed that his pre-election caucus had been attended by "over two hundred persons" and his opponents' by "not to exceed one hundred." He alleged that "about eighty" of his supporters "had been

overawed or through misrepresentation induced to give the movement a cold shoulder" and another 125 had been lured away by bribes of up to $25 or drink.

Beach got his revenge at the village election the following year. The old board did not seek election and a "conciliatory" group of five men (not including Beach) were chosen with only token opposition. This seemed to bring to an end the bitter conflict, though the financing remained a struggle for some time to come. Nevertheless, the modernization of Brockport's system of higher education was assured.

Union Elementary School

The modernization of the Brockport school system meant, essentially, the replacement of three district schools by a "graded union school." That process was long, difficult, and contentious and was accomplished only by the intervention of powerful outside forces.

One of the few functions of the Town of Sweden after its 1814 formation was the provision of education for its children. It established eleven school districts. When the village was laid out in 1822, it was located in District 4. The first school in the village was "in one end of a small building west of Main Street, right in line with the canal."[1] It had to be moved to North Main Street to make way for the canal. A bit later, the school was housed in the basement of a private home on State Street where the Presbyterian Church is now. Still before the canal reached Brockport and several years before the village was chartered in 1829, the first schoolhouse was built on Main Street, a two-story brick structure where the Baptist Church is now.

About 1830, that building was replaced by three one-story district schools. The West School was on Utica Street where the Monika Andrews Children's Park is now. It was demolished in 1907 to make way for the Grammar School. The East School was on the northwest corner of Union Street and Park Avenue. It survived until the 1960s and was replaced by a private home. The North School was on Fayette Street opposite the west end of Frazier Street. It was converted into a private home that still exists.

The village also had a Catholic parochial school that enrolled some 120–150 children. Furthermore, the agreement with the state when the Normal School was established provided that its Training School would enroll 120 village children in its primary and intermediate divisions without charging tuition.

Each district school was administered by officers who were largely autonomous. Each had three trustees elected for staggered three-year terms, a clerk, a tax collector, and a librarian, all elected annually. The trustees were not allowed to receive salaries, but the other officers were paid small stipends. Each school had a part-time janitor who was appointed by the trustees.

The trustees levied the taxes (usually 1 percent of the assessment), established the budget, and hired and fired the teachers. The districts also received subsidies

from the state, the amounts being based on pupils' attendance. Children were much less consistent in their attendance than is now the case. For instance, in 1893, the ten towns in Monroe County had 5,385 children enrolled, but average daily attendance was 3,098.

Each school had two classrooms and two teachers. The teachers served on a school year basis, and they could not gain tenure, but were often hired for successive years. They were almost always women. A typical teacher's salary was $150, though they varied widely.

All adult residents in the district could attend the annual business meetings and vote for the officers and budgets if they were citizens who "owned or hired" real estate in the district on which the school tax was paid or had schoolchildren in their households or paid a tax to the town on personal property assessed at $50 or more. Initially, the suffrage was restricted to men, but was extended to women in 1880. This was interpreted to mean that only the head of the household could vote, but in 1886, the legislature clarified this by allowing both parents to vote unless the children in the household were not members of the family when only the head of the household could vote. In 1893, 186 women were registered to vote in school elections in the Town of Sweden.

Women often attended the annual meetings, sometimes outnumbering the men. Participation by women was encouraged as they were believed to be a beneficial influence on the proceedings. Typically, they were elected to the clerk and librarian offices. The *Republic* mentioned a number of cases where women were chosen trustees in neighboring municipalities, but no woman became a trustee in Brockport until 1905. In that year, Mrs. F. H. Shafer was elected to a three-year term and was re-elected when that expired.

A common practice for teachers in the early district schools was to "board around." That is, they supplemented their incomes by taking their meals and lodgings with the families of their pupils, going from one home to another on successive weeks. Whether "boarding around" was a practice in Brockport is not clear from the surviving accounts. The parents seem to have regarded this practice as a privilege, rather than an imposition. One former teacher in Sweden recalled this experience in his first year of teaching:

> Job, on horseback, rode up to my boarding place, called me out, and said, "Schoolmaster, you'll have to give up your school. The scholars are all leaving and there are so few of them left now that the taxes will come too heavy on us." I asked … the cause of their leaving. He replied, "The folks all say you can board at the White House but not at the brown and log houses." The secret was out. The majority of the children came from the brown and log houses and their folks felt slighted because I did not board there as long as at the other houses and so the children were taken from school.

In 1896, the state passed a compulsory education law. All children from age eight to thirteen and all children fourteen and fifteen years old who were not employed were required to attend at least eighty school days a year. Also, municipalities were required to employ truant officers to enforce the law. The parents of delinquents were subject to fines of $5 for a first offense and $50 thereafter, imprisonment for not more than thirty days or both fine and imprisonment. In January 1897, Brockport's truant officer made his first arrest.

Throughout the 1870s and 1880s, the *Republic* reported a number of area municipalities that had "graded union" schools, while Brockport continued with its ungraded district schools. In the late 1890s, the state began to put pressure on municipalities to consolidate schools. In 1899, it passed a Consolidated School Law that conferred on School Commissioners the authority to force such mergers.

At the time, the school systems in Monroe County were under the authority of three popularly-elective School Commissioners, on the east side, the west side, and Rochester. Chauncey Brainerd, the west side commissioner, applied pressure on Brockport. In 1900, he advocated "one central school" for the village and threatened to condemn the west and north district schools as too derelict for their purposes. In 1901, he merged the three districts and a district just south of the village into one district with graded instruction.

This aroused the ire of the village board. At its April 15 meeting, Mayor Adams presented a recommendation that the board go on record as opposed to the consolidation of the district schools with the ultimate view of a union school. A large majority of the board were evidently in favor of the recommendation, but the matter was put over one week.

The following week, the board adopted a resolution disapproving the commissioner's action:

> ... for the reason such action will add $10,000 annual expense to the village and was taken without consulting the people of the Village or the School Districts ... and is without their consent and against their will; that the arrangement of districts with a school in each is more satisfactory to the people who have small children: that the commissioner is not the master but the servant of the people and should have consulted with his principals before making the order.

Notwithstanding the protests of the board, when the 1901 school year began, graded instruction was introduced. The north and east schools held first and second grades in one room and third and fourth grades in another. The west school offered seventh, eighth, and ninth grades. The ninth graders were to be prepared to take the entrance exam for the Normal School. A seventh teacher rotated among the buildings, teaching penmanship, vocal music, and drawing. The school south of the village was closed.

Meanwhile, at the annual district meeting on August 8, a committee was appointed to inspect the schools and report back. It did so at an August 22 meeting, recommending that "a new building be constructed adequate for the accommodation of from 350 to 400 students at a cost of about $20,000." The recommendation was referred to a special meeting scheduled for the following week. At the adjourned meeting, despite a plea by Commissioner Brainerd, the recommendation was defeated—65:151 with one blank ballot.

In 1902, Fred W. Hill was elected westside school commissioner, where he served for thirty years. He was well-known in Brockport, having begun his teaching career in Sweden. This may have helped turn sentiment around, but the most important factor was the dilapidated state of the school buildings. The West School was so lacking in space that some of its classes met in the Normal School. In 1903, the district appointed a committee to inspect the buildings and report on needed repairs. It noted the need for $850 worth of repairs on the West building and $600 on the North building. No action was taken on the proposal.

The next step forward was at the annual meeting in August 1904. A proposal was presented to consider the construction of a union school. For action to be taken, petitions were required with at least fifteen signatures from each of the former districts. Again no action ensued.

In April 1906, a lively public discussion of the issue began. "Citizen" published a letter in the *Republic* describing the many advantages he perceived in a union school. Editor Beach weighed in by advocating a solution through the Normal School. A week later, he returned to the fray. Negotiations were underway for the construction of a portion of a Rochester–Buffalo electric rail line through the village. Beach proposed that the village exact a franchise fee adequate to pay for a school building. Banker Morton Minot, whose wife was a district trustee, argued in favor of a new school.

In May 1906, the final blow to the opponents of a school was dealt by a report from the state inspector of schools. He said that "the buildings are unsanitary and wholly unfit for school purposes" and that "none of them are worth repairing." He complained of the "lack of heat, the utter lack of any system of ventilation, and the unsanitary condition of the water closets." He "urgently" recommended that "a new modern grade school building be constructed of sufficient size to accommodate all children of school age residing within your district."

The 1906 annual meeting accepted his recommendation by voting (52:27) to build an eight-room school on the site of the West district school at a cost not to exceed $20,000. The main opposition seems to have concerned the location of the school. Eastsiders objected to the west side having both the Normal School and the Grammar School and that their children would have to cross Main Street to get to school. Construction began in November, bonds to finance

the project were approved in March 1907, and instruction in the new building began with the opening of the 1907–08 school year in September.

Long after neighboring communities had established "graded union" schools, Brockport finally fell in line. The earlier heated opposition, both by the taxpayers and the village board, had yielded to the reality that the district schools that had been such a cherished part of the community for more than seventy years had outlived their usefulness. Modern elementary education had arrived in Brockport.

The Grammar School served the village well for forty-nine years, until replaced in 1956 by the Elizabeth Barclay Elementary School, named for the first principal of the Grammar School. It shares a public school campus with two other elementary schools, the A. D. Oliver Middle School, the Brockport High School, and the administrative offices of the Brockport Central School District adjacent to the campus of the SUNY College at Brockport.

Elections

Elections in Brockport were quite different in 1916 from what they had been in 1866. The changes were generally toward more democracy, but not entirely. Most of them were dictated by outside forces, but some were generated internally. Whether from the outer world or local, they reflect quite accurately what was happening across small town America and, thus, are a legitimate part of a case study of small town modernization.

One very important democratizing change was the introduction of the secret ballot and the voting machine. In the 1860s, voting in the village took two forms. First, a meeting open to all registered voters decided by show of hands or *viva voce* whether to approve any taxes of more than $200 proposed by the trustees, as required by the 1852 charter revisions. Second, elected officials were chosen by paper ballots. Each candidate or slate of candidates distributed to their supporters small slips of paper on which were printed their names and the offices they sought. Their supporters would deposit them in the ballot box at the polling station. Sometimes the competing slates printed ballots on different color paper. Any poll watchers could tell what choices the voters made. An 1880 law prescribed 3×8-inch plain white paper ballots printed in black ink. Due to the absence of partisanship in Village elections, there were often several tickets— "half a dozen" in 1886—with some candidates appearing on more than one slate. In 1888, the voters were faced with "tickets of almost every conceivable combination" and in 1890 there were "seven or eight." An 1890 law put an end to this confusion. Thereafter, two tickets were presented at each election

One result of this was that there was vote buying. This is suggested quite openly by an 1871 news item in *The Brockport Republic* reporting on the Town

of Sweden's vote in the state election.[2] It said: "[T]here was very little splitting or buying of votes—which must have disappointed quite a number who hung back some time, apparently for remuneration." Similarly, in its report on the 1869 town election, the *Republic* felt constrained to say that "no sheriffs from Rochester or elsewhere needed to keep the peace. Very little intoxication was visible. Little if any money was used in the election."

In 1880, the state introduced the so-called Australian ballot, which made secret voting possible. The act specified in great detail the appearance of the ballot. The names of all candidates for offices were to be printed on a plain white sheet of paper. Electors would vote by placing marks by the names of their preferred candidates. The ballots would also describe briefly all propositions that had been proposed and enable the voters to indicate their support or opposition to them. Candidates could also enter the fray by submitting their names and office sought on home-made ballots, called "pasters."

The lever-operated voting machine, which also permitted secrecy, was first used in Lockport in 1892 and was adopted by Brockport by 1894, when voters could choose between the machines and the earlier system. To ensure the secrecy of the ballot, voters made their choices in a curtained booth. Later in the period, machine voting replaced paper ballots entirely. Before the secret ballot, bribery was a buyer's market. The briber could tell if the voter did what he had been paid to do. The secret ballot changed that to a seller's market. The briber could not tell how the voter cast his ballot.

Elections were often fought fiercely and there were even hints of violence, especially during the early part of the period. This is suggested, for example, in an 1871 *Brockport Republic* report on the Town of Sweden election. It said: "The canvass was conducted spiritedly though good naturedly … but some of the Democrats got to quarreling among themselves, and there was a bit of a row which some feared would result in a shooting affray. Nothing, however, very serious happened."

The suffrage underwent significant change during this period, especially if the year 1917 is included. Universal manhood suffrage had existed for some time already, though some property ownership requirements remained for school district voting and voting on financial propositions. During this period, beginning in 1880, women became involved in the electoral process, culminating in full suffrage rights in 1917, three years before ratification of the Nineteenth Amendment. Before they got full suffrage in New York State, women who owned property could vote on propositions to raise taxes and the *Republic* reported that eight of them did in a 1915 referendum. Also, after 1880, they could vote in school board elections if they owned or rented property in the district or had children in school. This is discussed more fully in the section on schools above.

In 1907, the *Republic* reprinted Section 41 of the village law, which set the qualifications for voters:

First. To entitle him to vote for an officer he must be qualified to vote at a town meeting of the town in which he resides, and must have resided in the village thirty days next preceding such election. Second. To entitle him to vote upon a proposition, he must be entitled to vote for an officer, and he or his wife must also be the owner of property in the village, assessed upon the last preceding assessment-roll thereof. A woman who possesses the qualifications to vote for village officers, except the qualification of sex, who is owner of property in the village assessed upon the last preceding assessment-roll thereof, is entitled to vote upon a proposition to raise money by tax or assessment.

African-Americans enjoyed full suffrage from at least 1870. In fact, *The Brockport Republic* reported that "The 15th amendment to the Constitution was put into operation, the colored men voting the same as others" even though it was not ratified until four days after the election.[3] African-Americans even served as party leaders. Anthony Barrier was a leading member of the Republican Party in the Town of Sweden. His name appeared frequently among Republican leaders in the village and town and among "colored" Republicans in the county. For instance, he was among only four representatives of the local Republican committee to attend the inauguration of President Garfield in 1881. His son, George, was a leading member of the Republican Party in Detroit and held two patronage jobs as a result. Two other Brockport African-Americans, William Page and Troy A. White, were also active in the local and county Republican Party. Page was sufficiently prominent to be elected to chair a party nominating caucus in 1882.

During the early decades of the period, nominations were decided in party caucuses, sometimes only a day or so before the election. The state legislature enacted a law in 1883 requiring that political parties choose their candidates through primary elections in municipalities with populations over 200,000. In 1898, that requirement was imposed on parties in all cities and towns. The Republican primary in the Town of Sweden drew over 600 voters with the organization's slate defeating the opposition by about 250 votes for the choice of delegates to the Assembly District convention.

A number of other changes occurred during that period. For one thing, the terms of the village board members were lengthened. All were one-year terms in 1866, but had become two-year terms by 1916. Another change concerned the electoral process for the village president (later termed the mayor). In the 1866 system, the trustees selected one of themselves to be president at the organizational meeting after each election. In 1871, this was changed so that the president was elected directly by the voters.

The list of village offices subject to election changed. From 1866 through 1872, they were five trustees, clerk, treasurer, two or three assessors, collector, police constable, police justice, street commissioner, and pound keeper. From

1873 through 1916, they were president, five trustees, treasurer, collector, and two assessors (increased to three in 1879), except that collector was omitted in 1915 and 1916. Many of the candidates for those offices were unopposed. For instance, John R. Davis was unopposed as treasurer from 1894 through 1916.

The list of town offices for which Brockporters voted changed much less during that period. In 1866, they were supervisor, clerk, collector, two justices of the peace, two overseers of the poor, assessor, commissioner of highways, five constables, and four election inspectors. Elective offices kept being added. By 1879, the positions of two excise commissioners had been added, and by 1880, there were eight, and by 1882, nine election inspectors. A game constable was added by 1882. In the 1915 election, the elective offices were supervisor, clerk, two justices of the peace, police justice, two assessors, collector, five constables, overseer of the poor, superintendent of highways, and two school directors. The voting on excise commissioners was, in effect, deciding whether to introduce licensing of liquor sales in the town. The town offices at neither time included trustees. The candidates took stands on that issue.

Much about village elections remained the same throughout the period. For instance, efforts to make the board positions more attractive by providing salaries for the trustees failed. One proposition to pay the trustees salaries totaling not more than $1,000 for the five of them was defeated by a vote of 157:49.

Also, throughout the period there was much instability in office. In that fifty-year period, twenty-four men held the office of president. Thomas Cornes, John H. Kingsbury, and George R. Ward each served five times, Luther Gordon and Franklin F. Capen four times each, and George B. Harmon three times. However, none of them served more than three consecutive one-year terms. So, no president remained in office as long as a single mayoral term today, much less Jim Stull's twenty years or to the eight years of Mary Ann Thorpe and Margay Blackman.

Trusteeships were similarly unstable. Ninety-five men occupied the four trusteeships during that period. They served terms of varying length, two years, one year, or simply to fill a vacancy. Edgar Brown was elected nine times between 1870 and 1880, Nelson A. Smith was elected seven times between 1877 and 1885, and Thomas Cornes was elected seven times between 1858 and 1868. On the other hand, fifty men—more than half—served a single term.

Finally, almost every election throughout the period included voting on propositions. Many matters later handled by the board, with or without public hearings, were decided by the electorate. Often, it seems that the board referred business to referendums simply because it had difficulty deciding them. Some examples: in 1870, they voted $300 additional for the Highway Fund and $150 to pay for a lawsuit. At the other end of the period, in 1915, the voters approved the purchase of a motor fire truck for $1,000, but in 1916, they defeated a proposition to buy one for $2,000. Year after year, they considered proposals to sponsor summer band concerts, approving them in 1911 and 1913, but rejecting

them in 1910, 1912, 1914, and 1916; in 1910, they refused to make the offices of village clerk and street commissioner elective; and in 1914 they refused to create a Board of Water Commissioners.

In one very important respect, practice did not change during that period—and, indeed, to the present day. Village elections were always non-partisan—that is, the tickets bore only the names of local parties. Often, more than two tickets were submitted, but many candidates appeared on more than one slate. An exception was 1891, when a Democratic ticket was nominated. All of its candidates lost and the experiment was not repeated. On the other hand, Town of Sweden elections throughout the period were always partisan, Republicans and Democrats, as they are today. As the Democrats were out of favor because of their alleged lukewarm position on the Civil War, they sometimes concealed their ticket under the label of "People's" or "Workingman's." However, at least in the 1880s, party loyalty seems to have been low. For instance, in 1883, only forty-one straight party line tickets were voted of the 934 ballots cast.

The partisan situation in 1866 was distorted by the split in the Republican Party between the supporters and opponents of U.S President Andrew Johnson. Johnson, who was a Democratic Senator from Tennessee, had been selected by Abraham Lincoln as his running mate in the 1864 election to symbolize Lincoln's desire to unify the country. After succeeding to the Presidency, however, Johnson aroused the opposition of the Radical Republican Congressmen by pursuing what they regarded as too lenient a policy toward the former Confederacy. That split was reflected locally by a division in the Republican Party with one faction joining the local Democratic Party and supporting the President.

Fire Department

The village charter, dated April 6, 1829, authorized the village board to equip fire companies and to appoint "a company of firemen not to exceed twenty-five to each fire engine." It exempted taxes to pay for fire-fighting equipment from the general requirement that "no tax shall be raised without the consent of a majority of the voters present at any legal meeting." The village board raised no fire companies and bought no equipment for some time. Instead, it passed the fire-fighting responsibility on to the residents by enacting the following ordinance on July 1, 1829:

> Every resident owner (or occupant) of any building in the said village ... shall at all times hereafter provide and ... keep the following number of fire buckets, *viz.*: for each and every building having one or two fire places or stoves therein, one fire bucket; for each and every building having three or four fire places therein, two fire buckets; and for each and every building having more than

four fire places or stoves therein, three fire buckets, with the owners name painted on each bucket and that he, she, or they shall keep the same hanging up in some conspicuous place in the front part of such building, and not be used to any other purpose than the extinguishment of fires—and every owner or occupant ... who shall refuse to keep the number of fire buckets and in the manner provided by this ordinance, shall for every such offence, neglect or refusal, forfeit and pay to the said Trustees the sum of five dollars.

The Brockport Free Press weekly newspaper on December 22, 1830, complained about the lack of board action in creating fire companies and announced that the village board had called a public meeting for the following week to deal with the issue. The next issue of the *Free Press*, dated December 29, published a notice that there would be "a meeting of the inhabitants of the village of Brockport at the house of Austin Wales on the 29th instant, at 6 o'clock P. M. for the purpose of taking measures to raise money sufficient to procure a Fire Engine, Fire Hooks and Ladders." (Rather short notice.)

The Free Press never published a report on such a meeting, if, indeed, it was held. Nor did it report on the fire that it said had precipitated that action nor on any fire in Brockport until it ceased publication in 1833, though it reported on many other fires in cities across the country.

The village board finally got into the firefighting business on May 1, 1832, by ordering one hand-pumped fire engine to cost $450 and, the following July, by appointing the first fire company, Water Witch Engine Company No. 1. Later that year, an engine house was built to house the equipment, and on July 2, 1837, a second fire company, Fire Engine Company No. 2, was formed.

Those two companies remained active until the early 1860s, when company membership dwindled to the vanishing point and equipment deteriorated. The trustees and voters repeatedly turned down requests to buy new equipment. By 1867, the village board threatened the last remaining company with disbandment. In effect, the village had abandoned the firefighting business.

The second time Brockport entered the firefighting business came, like the first one, after a disastrous fire, the infamous Market Street fire of January 12, 1877. All of the commercial buildings on both sides of the street, except those fronting on Main Street, were destroyed. In its aftermath, the voters approved a bond issue of $6,000 for the purchase of fire equipment, four new fire companies were organized, they were united in the Brockport Fire Department, and John A. Getty was appointed chief. Brockport had gotten back into the firefighting business.

In 1884, a village hall was built that included five bays for fire engines on the ground floor and other facilities to accommodate the Fire Department. In 1904, the Capen Hose Co. firehouse was added on south Main Street.

7
Conclusion

Life for Brockporters was much different in 1916 than it had been when they were fifty years younger. The character of the village was revolutionized in that period. They now had municipal water, sewers, and firefighting; telephones and home delivery of the mails for greatly improved means of communication; bicycles and automobiles, concrete sidewalks and hard-surfaced streets for safer and faster transportation; electricity for better illumination; and power for mechanical devices to make homemaking easier.

Before 1866, the village had been transformed by the introduction of manufacturing, the founding of the Brockport Collegiate Institute, the arrival of the telegraph, illuminating gas, and the railroad. The canal was really part of the founding of the village, so it does not count as transformative. These certainly were important developments and the village was changed significantly from 1822 to 1866. However, in terms of the number of developments and the effects on the lives of the villagers, they do not amount to as much as what happened in the next half century.

Many changes have affected Brockport since 1916. However, they have been incremental improvements, not transformative. Streets and sidewalks have become better. Telephone communications have improved greatly, especially since the iPhone was introduced, but the basic principles are unchanged. Radio and television have come to the village, but they involved no effort on the part of the residents or the municipality. The same with air travel.

Many of the transformative developments of the 1866–1916 period aroused great controversy and required great effort by the village leaders. The normal school, the union elementary school, the electric railroad, the water system were among them. Other innovations required much adjustment on the part of the residents. The automobile, the telephone, concrete sidewalks were among them. Some came much more easily, like home delivery of the mail, the fire department, and electricity. Often the village benefited from the pioneering of nearby municipalities, but sometimes it took the lead.

In conclusion, it seems fair to say that the village today is what it is pretty much because of those fifty years. Brockporters owe a tremendous debt of gratitude to their predecessors, both the leaders and the many followers, for their accomplishments.

Endnotes

Chapter 1

1. Howk.
2. *Ibid.*
3. Beeney
4. *The Brockport Republic* [BR] 11/12/1963.
5. BR 10/3/1861.
6. *Brockport Village Board Minutes* [VBM] 4/27/1863.
7. BR 2/18/1864.
8. *Ibid.*
9. BR 2/25/1864.
10. *Ibid.*
11. Chapter 557.
12. BR 11/22/1860.
13. BR 2/23/1860.
14. BR 3/7/1861.
15. BR 3/6/1862.
16. BR 3/5/1863.
17. BR 4/5/1860.
18. BR 4/4/1861.
19. BR 4/3/1862.
20. BR 4/9/1863.
21. BR 4/7/1864.
22. BR 9/5/1861, 9/12/1861.
23. BR 11/7/1861.
24. BR 10/10/1861.
25. BR 11/7/1861.
26. BR 12/16/1860.
27. BR 6/28/60.
28. BR 8/9/1860.
29. BR 8/16/1860.
30. BR 8/23/1860.
31. BR 8/30/1860.
32. *Ibid.*
33. BR 9/20/1860.

34. BR 11/8/1860.
35. BR 9/13/1860.
36. BR 3/7/1861.
37. BR 10/23/1862.
38. BR 4/5/1860.
39. BR 9/13/1860.
40. BR 10/23/1862.
41. *Biographical Directory of the American Congress*, GPO, Washington, 1961.
42. BR 4/4/1861.
43. BR 1/26/1860.
44. BR 3/18/1860.
45. BR 9/19/1861.
46. BR 6/26/1862, 2/12/1863.
47. BR 9/20/1860.
48. BR 3/15/1860.
49. BR 5/17/1860.
50. BR 10/4/1860.
51. BR 4/24/1862.
52. BR 9/22/1864.
53. BR 7/26/1860, 9/20/1860, 7/25/1861, 8/22/1862.
54. BR 12/6/1860.
55. BR 1/10/1861.
56. BR 12/6/1860, 4/11/1861, 2/5/1863, 3/19/1863, 2/18/1864.
57. BR 2/23/1860, 5/30/1861.
58. BR 6/12/1862.
59. BR 5/21/1863.
60. BR 11/29/1860, 12/6/1860, 6/6/1861.
61. BR *Orleans American* 5/22/1862, BR 12/25/1862.
62. BR 4/16/1863.
63. BR 1/26/1860.
64. BR 4/12/1860, 5/23/1861.
65. BR 1/26/1860.
66. BR 8/6/1863.
67. BR 1/22/1860.
68. BR 4/10/1862.
69. BR 3/19/1863.
70. BR 8/13/1863, 8/20/1863, 5/12/1864, 6/23/1864.
71. BR 11/22/1963.
72. BR *Ibid.*, 8/20/1863.
73. BR 10/23/1862, 12/23/1862.
74. BR 2/5/1863.
75. BR 8/29/1861, 9/26/1861, 12/26/1861, 10/23/1862.
76. BR 8/15/1861, 1/23/1862, 10/17/1861.
77. BR 10/17/1861.
78. BR 12/11/1862.
79. BR 10/11/1863, 1/14/1864.
80. BR 4/14/1864.
81. BR 3/23/1873.
82. BR 12/19/1862.
83. BR 2/6/1862, 7/17/1862.
84. BR 3/15/1860.
85. BR 6/7/1860.

Endnotes

86. BR 6/23/1864.
87. BR 10/13/1861.
88. BR 11/28/1861.
89. BR 12/17/1863.
90. *Ibid.*
91. BR 1/3/1861.
92. BR 5/21/1863.
93. BR 4/12/1860.
94. BR 6/21/1860, 6/27/1861, 6/5/1862, 6/23/1864.
95. BR 6/28/1860, 6/9/1862, 3/19/1863, 5/21/1863, 6/25/1863, 6/16/1864.
96. BR 8/30/1860.
97. BR 1/3/1861.
98. BR 2/26/1863, 9/15/1864.
99. BR 11/6/1862, 5/28/1863.
100. BR 2/16/1860, 12/13/1860, 1/3/1861, 12/27/1860, 2/5/1863, 6/27/1861, 8/22/1861, 6/25/1863, 8/20/1863, 12/24/1863, 4/21/1864, 6/30/1863.
101. BR 9/6/1860, 9/13/1860, 7/17/1862, 9/3/1863.
102. BR 9/3/1863, 3/31/1864.
103. BR 10/15/1863, Dedman 71, 77.
104. BR 10/18/1860.
105. BR 4/16/1863, 3/3/1864.
106. BR 9/6/1860, 6/13/1861.
107. BR 2/23/1860.
108. BR 3/15/1860, 3/20/1862.
109. BR 6/11/1863, 7/28/1864.
110. BR 1/3/1861.
111. BR 12/4/1863.
112. BR 6/10/1864, 4/27/1863, 6/9/1862.
113. BR 12/6/1860.
114. BR 12/13/1860, 1/10/1861, 1/31/1861.
115. BR 1/26/1860.
116. BR 3/1/1860.
117. BR 10/25/1860.
118. BR 11/22/1860.
119. BR 3/25/1861.
120. BR 4/19/1860.
121. BR 5/3/1860.
122. BR 7/31/1861, VBM.
123. BR 6/20/1860.
124. BR 12/11/1862, 3/17/1864.
125. BR 3/29/1860.
126. BR 10/18/1860.
127. BR 4/21/1864.
128. BR 6/9/1864, VBM 5/27/1864.
129. BR 7/23/1863.
130. BR 1/14/1864.
131. BR 5/30/1861.
132. BR 9/29/1864.
133. BR 2/11/1861.
134. BR 7/5/1860.
135. BR 3/1/1860.
136. BR 5/24/1860.

137. BR 1/24/1861.
138. BR 1/23/1862.
139. BR 7/26/1860.
140. BR 8/1/1861.
141. BR 8/7/1862.
142. BR 8/4/1864.
143. BR 7/5/1860.
144. BR 7/5/1860.
145. BR 7/11/1861.
146. BR 7/10/1862.
147. BR 7/2/1863, 6/30/1864.
148. *Orleans American* 5/29/1862.
149. BR 3/1/1860.
150. BR 4/19/1860.
151. BR 12/20/1860.
152. BR 4/11/1861.
153. BR 3/29/1860, 5/17/1860, 11/22/1860, 1/10/1861, 5/9/1861, 8/29/1861, 12/26/1861, 4/17/1862, 6/12/1862, 2/5/1863, 4/9/1863, 6/25/1863, 9/10/1863, 11/12/1863, 1/7/1864, 8/4/1864.
154. BR 3/1/1860, 12/20/1860, 4/18/1861, Orleans American 5/22/1862, 9/10/1863.
155. BR 3/1/1860.
156. BR 12/20?1860.
157. BR 5/16/1861.
158. BR 12/13/1860.
159. BR 10/11/1860.
160. BR 9/8/1864.
161. BR 2/6/1862.
162. BR 7/23/1863.
163. BR 6/7/1860.
164. BR 6/21/1860, 9/20/1860, 5/30/1861.
165. BR 1/19/1860, 6/13/1861.
166. BR 3/22/1860, 5/1/1862, 11/8/1860, 1/26/1860, 6/6/1861.
167. BR 1/26/1860, 3/22/1860, 2/1/1861, 3/21/1861, 5/7/1863, 8/20/1863, 6/16/1864.
168. BR 3/15/1860.
169. BR 3/15/1860.
170. BR 10/4/1860.
171. BR 5/1/1862.
172. BR 12/13/1860.
173. BR 3/17/1864.
174. BR 7/2/1863, 7/23/1863.
175. Martin 77.
176. BR 10/15/1863.

Chapter 2

1. Winder typescript unnumbered pages.
2. Smith 112
3. Tuttle typescript unnumbered pages.
4. Chesnut 127
5. BR 10/07/1907.

Chapter 5

1. Gordon 4
2. *Ibid.*

Chapter 6

1. BR 12/12/1889
2. BR 11/9/1871
3. BR 4/7/1870

Bibliography

My most important source was the issues of the weekly newspaper, *The Brockport Republic*. I also cited the following publications:

Beeney, B., and Sweden, C.," Grown, Exports Teachers," *Rochester Democrat & Chronicle*, June 12, 1955, quoted in Baker, E. B., *Early History and Folklore of the Town of Sweden* (paper for English 564, College at Brockport, May 23, 1957)
Chesnut, E., *Encyclopedia of Brockport, Western Monroe Historical Society* (Brockport, NY, 2010)
Gordon, W. R., *The Story of the Buffalo, Lockport, and Rochester Railway 1908-1919 the Rochester, Lockport, and Buffalo Railway April, 1919–April 30, 1931* (1963)
Howk, C., *Brockport Main Street Historic Resources Survey* (1997), 5 vols.
Martin, C. E., *The Story of Brockport for One-Hundred years, 1829-1929* (Brockport, 1919)
Orleans American weekly newspaper, Albion, NY
Smith, M. E., *Remembering Hamlin 1802-2002* (Town of Hamlin, Hamlin, 2005)
The Brockport Free Press weekly newspaper
Tuttle, R., *The Village of Brockport* (Brockport, 1946, typescript)
Winder, G. M., *Managing Business at a Distance: A Geography of Reaper Manufacturer D. S. Morgan and Co.'s Correspondence, 1867* (typescript, Toronto, 1999)